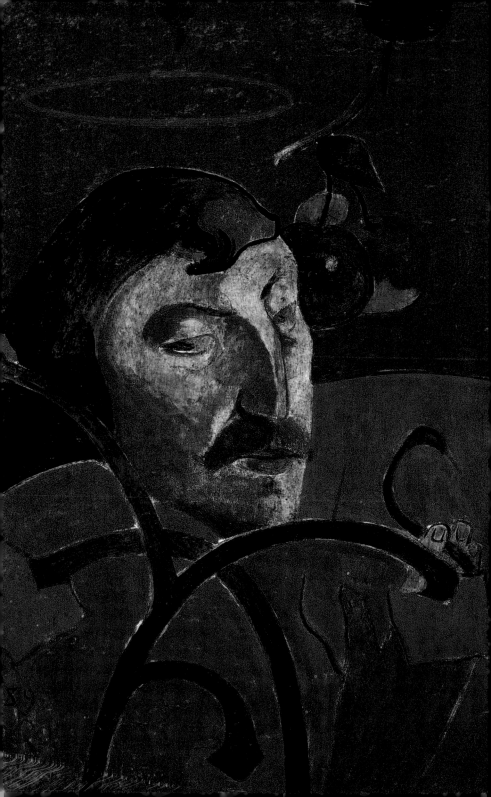

ArtBook
Gauguin

DK

DORLING KINDERSLEY
London • New York • Sydney • Moscow
Visit us on the World Wide Web at http://www.dk.com

Contents

How to use this book

This series presents both the life and works of each artist within the cultural, social, and political context of their time. To make the books easy to consult, they are divided into three areas which are identifiable by side bands: yellow for the pages devoted to the life and works of the artist, light blue for the historical and cultural background, and pink for the analysis of major works. Each spread focuses on a specific theme, with an introductory text and several annotated illustrations. The index section is also illustrated and gives background information on key figures and the location of the artist's works.

■ Page 2: Paul Gauguin, *Self-Portrait with Halo*, 1889, National Gallery of Art, Washington.

1848–1885

The formative years

1886–1890

Brittany and other places

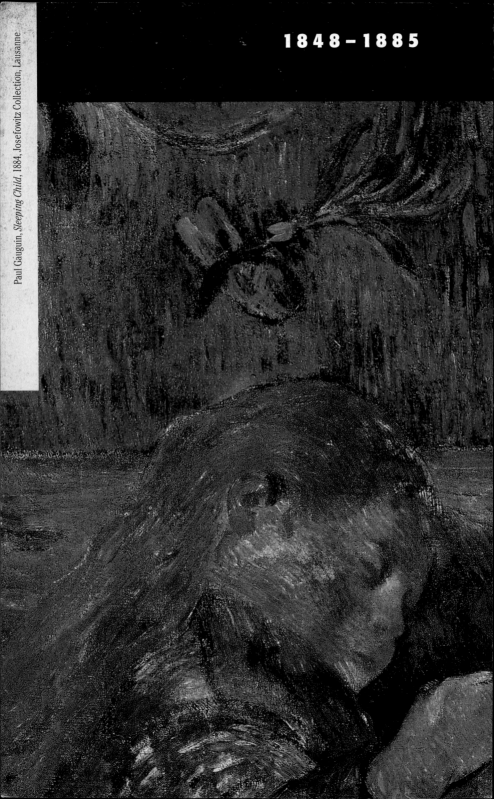

The formative years

LIFE AND WORKS

1848–71: childhood and youth

Eugène Henri Paul Gauguin was born in Paris, at 52 rue Notre-Dame-de-Lorette, in the district of Montmartre, on June 7, 1848. The family of his mother, Aline Chazal, belonged to the Spanish nobility that had moved to Peru at the time of the American conquests. His father Clovis was a political journalist for *Le National*. In October 1851, foreseeing the seizing of power by Louis Napoleon, whom he had opposed, Clovis and his family left for Peru. During the passage he died as a result of an aneurysm and a fit of rabies. Aline and her children Paul and Marie, who was two years older than her brother, were taken in by an uncle, Pio Tristan, a rich notary in Lima. In 1855, following the death of her father-in-law, Aline decided to return to Orléans and live with another uncle, Isidore; later she moved to Paris. Paul went to boarding school in Orléans, but after the years in Peru he found it hard to adapt to the French language, and his academic results were poor. In 1865 he signed up as a sailor. Two years later Aline died, and Paul Gustave Arosa was assigned to him as guardian. At the end of his military service, Gauguin returned to Paris, where Arosa found him a job with Bertin, a leading firm of stockbrokers.

■ A shrewd businessman, a good art photographer, and an expert in modern painting, Gustave Arosa had been a friend of Gauguin's mother since childhood. A cultured and sensitive man, he was one of the first to take a serious interest in the Impressionists and to include their works in his collection.

■ Bottle with stirrup-shaped handle and pouring spout, Moche culture, Peru, Museo Arqueològico Rafael Larco Herrera, Lima. Gauguin was proud of his origins, and believed he had Inca blood in his veins.

■ Guyon, *A Terrace in Algiers*, Private Collection. In 1870 the Franco-Prussian War broke out. Gauguin took part in military actions in the Mediterranean, particularly in Algiers.

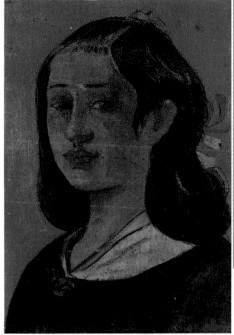

■ Paul Gauguin, *Portrait of My Mother*, 1890, Staatsgalerie, Stuttgart. The artist painted this portrait 23 years after his mother's death, using, as a model, a photograph from her youth, and stressing her exotic features. Gauguin had a loving rapport with his mother and, in *Diaries of a Savage*, he paid her a glowing tribute.

■ Aline's mother, Flora Tristan y Moscoso, was a writer, journalist, and socialist activist. She wrote her autobiography, *Wanderings of an Outcast*, in 1838, and in 1844 was killed by her husband, engraver André Chazal.

■ François Etienne Musin, *The Port of Calais*, Private Collection. Gauguin signed up to sail on the *Lusitane*, then the *Chili* and the *Jérôme-Napoléon*.

The France of Napoleon III

The revolution of February 1848 had caused the abdication of Louis Philippe and the birth of the Second Republic. In the same year, on December 10, still shaken by the insurgence of the workforce in June, the French elected Louis Bonapart as president. After a coup d'état on December 2, 1851, Bonapart turned the republic into an empire, and adopted the name Napoleon III. In France, and especially in Paris, he started a grandiose building programme of public works, following the projects of Baron Haussmann. In a few decades 60,000 new buildings, including great public halls connected by wide boulevards, turned Paris into a veritable metropolis. Napoleon III's colonization policy led to the conquest of New Caledonia, Algeria, Senegal, and Cambodia and heavy political interference in China, Syria, and Mexico. However, in spite of the military success in the wars against the Austrians in 1859 and 1866, his foreign policy did not yield the expected results. The rapport with Italy became tense as a result of his support of the Papal State, and he failed in his attempts to control Luxembourg and conquer Mexico. The 1870 conflict against the Prussians marked the end of his empire.

■ *Inauguration of the Suez Canal*, 1869, Civic print collection, Milan. Between 1859 and 1864, France actively promoted the construction of the Suez Canal. This important technical work had many consequences, from a political and economic point of view.

■ Angelo Inganni, *The Zouaves on the Steps of St John in Brescia*, Musei civici d'arte e storia, Brescia. Napoleon III tried to usurp the Austrians' political control over Italy, but he only managed to annex Nice and the area of Savoy.

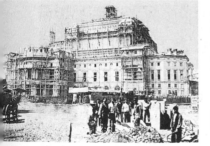

■ The construction of the Opéra started in July 1862. Designed by Garnier, it was opened on December 15, 1875. The building was used to store provisions during the 1871 siege of Paris and as a refuge for the members of the Thiers government during the Commune.

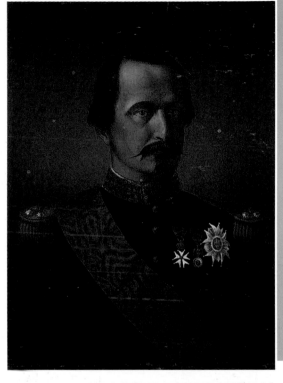

■ Born in 1808, Napoleon III was emperor from 1852 to 1870. After defeat in the Franco-Prussian War he fled to England, where he died in 1873.

■ An early example of a dry plate camera, this Waston Acme was manufactured in London in the early 1900s.

Photography and painting

In 1839, the French artist and inventor Louis-Jacques Mandé Daguerre developed a method of reproducing images by a photo-chemical process, the daguerreo-type. The process was soon improved upon, and became known all over Europe. A remarkable technical feat, photography led to a profound ideological and cultural revolution that was to transform the art of painting.

■ *Louis Napoleon visits the Barricades after the Coup of December 2, 1851*, Bibliothèque Nationale, Paris. In order to seize power, the future Napoleon III eliminated the republican opposition by reducing the electorate, controlling the press, and forming an alliance with the Church.

1872–78: his artistic début

Ⅰn 1872 Gauguin started work at Bertin's office, where he received not only a monthly salary, but a small share in the profits, affording him a good standard of living. One of his colleagues was Emile Schuffenecker, a young German man who became a close friend and shared his interest in painting. Gauguin visited exhibitions and museums, discussed art with Émile Bernard, Arosa, and gallery director Paul Durand-Ruel, and purchased works by Cézanne, Sisley, Monet, Manet, Renoir, Pissarro, and other Impressionists. Before long he began to paint, first under the guidance of Arosa's daughter, Marguerite, then, with Schuffenecker, he joined a course run by Colarossi. Through Arosa, Gauguin met a young Danish girl, Mette Sophie Gad, whom he married the following year, on November 22. In 1874 their first child, Emile, was born, followed by Aline in 1877, Clovis in 1879, Jean-René in 1881, and Paul in 1883. Between 1873 and 1874 Gauguin painted some still lifes and landscapes, one of which was exhibited at the Salon of 1876.

■ Taken in 1873, this photograph shows Gauguin aged 25. He was not handsome in the traditional sense of the word, but his lively, penetrating eyes commanded admiration and respect.

■ *Landscape*, 1873, Fitzwilliam Museum, Cambridge. Gauguin's early paintings were heavily influenced by Corot and the Barbizon school, named after a town near Fontainebleau. Many artists had gathered here to rediscover the Dutch and English landscape tradition.

■ *Undergrowth*, Private Collection, 1873. The composition and the handling of the paint reveal the uncertainty evident in Gauguin's early work.

■ Mette Sophie Gad was 23 years old when she first met Gauguin. She thought that the promising young clerk could replace her recently deceased father in the sphere of her affections, and fell in love with him.

■ *Mette Sewing*, c.1878, Bührle Collection, Zürich. The first few years of the couple's union were happy and serene, both personally and professionally, since Gauguin's career offered him great satisfaction. The sense of domestic peace conveyed in this work testifies to their happy family life.

■ *Autumn Landscape*, Private Collection, 1877. Although in this painting Gauguin still applied the color in a conventional manner, his work of this time was beginning to show an Impressionist influence inspired particularly by Camille Pissarro, whom he had recently met.

The Seine at the Pont d'Iéna

When this work was executed in 1875, painting was merely a hobby for Gauguin. Nobody, including the painter, could imagine that it would completely change his life. The painting is now housed in the Musée d'Orsay in Paris.

■ In the manner of the Impressionists, Gauguin's representation of this wintry landscape is fresh and spontaneous. It is a far cry from his later works, in which he mixed techniques and ideas drawn from sources as diverse as medieval art to Egyptian friezes.

■ The subject and style of this painting are clearly influenced by the Impressionist artist Armand Guillaumin and the Dutch landscape painter Johan Barthold Jongkind. Gauguin was a keen follower of their exhibitions, and often bought their works.

■ In early works such as this, Gauguin's palette is still made up of cold colors that give an impression of depth and magnitude, but also of stillness. The painting is carefully constructed with methodically applied brushstrokes.

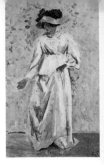

Camille Pissarro

The son of a Portuguese Jew and a Creole woman, Camille Pissarro was born in 1830 in St. Thomas, in the Antilles, and died in Paris in 1903. From 1855 he studied at the École des Beaux-Arts and the Académie Suisse, where he met Claude Monet. Although he had been accepted as a member of the Salon in 1859, he rejected its rigorous academic approach and, in 1863, he started to exhibit his works at the Salon des Refusés along with Manet, Jongkind, Cézanne, and Guillaumin. From 1866 he became a regular presence at the Café Guerbois, where the Impressionists used to meet, and his influence upon them was remarkable. The critics of the Impressionist movement found in Pissarro and Monet their favorite targets: in spite of his subjects' innocence and humility, Pissarro was harshly condemned for his stylistic innovations, such as the lack of shadows and revolutionary use of color. In 1870, following the Prussian invasion, Pissarro fled to London, where he met Durand-Ruel who became a dealer of his — and other Impressionists' — work. He worked in Pontoise in 1872, Eragny in 1884, and finally Paris from 1896 until his death. During this time, he took part in all the Impressionist exhibitions, becoming a role model for young artists such as Seurat, Signac, and Gauguin. He taught them a passion for nature and a taste for landscapes and painting *en plein air*, a technique which he fiercely supported. He experimented briefly with pointillist techniques, but later returned to his earlier style.

■ Pissarro, *Haymaking at Eragny*, 1891, Private Collection. Pissarro's paintings transmit his profound love of rural France and its villages and hamlets where life was dictated by the slow rhythm of the seasons. The light in this work is distributed evenly and is reflected, in the small brushstrokes, with a slightly veiled effect.

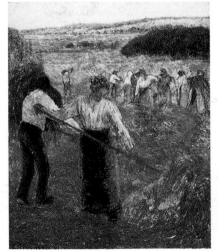

■ Pissarro, *Portrait of Jeanne*, c.1897, Private Collection. The artist was inspired by many themes, from simple subjects rooted in popular tradition, to refined and elegant ones.

■ Pissarro, *Female Peasant Seated*, 1880, Private Collection. Pissarro admired Corot and Delacroix, who had rejected the unquestioning cult of the classics imposed by the École des Beaux-Arts.

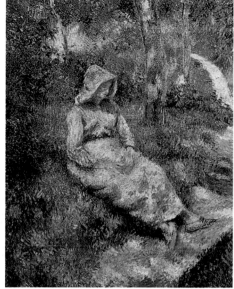

■ Pissarro, *Self-Portrait*, 1873, Musée d'Orsay, Paris. Pissarro met Gauguin in 1874, but they became friends only after 1878. The extrovert, articulate Gauguin appealed to the older artist, who became his first real mentor.

■ Pissarro, *The Port of Dieppe*, 1902, Private Collection. Pissarro's artistic training was difficult, and he became successful only late in life. He worked in some of the cheapest areas in Paris, such as Pontoise and Louveciennes.

■ Pissarro, *The Marketplace*, 1894, Private Collection. Gauguin was impressed by the way Pissarro portrayed country folk.

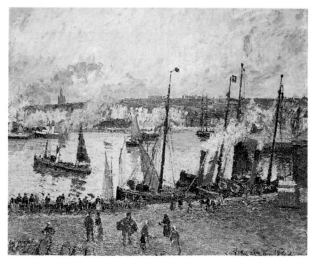

1879–81:
the first exhibitions

After the birth of Clovis in 1879, Gauguin moved with his family to a bigger apartment, from rue des Fourneaux to 8 rue Carcel, in which he had arranged for an extra room to be used as a workshop. In the same year, he was invited to show one of his sculptures at the fourth Impressionist exhibition, and he spent the summer in Pontoise with Pissarro, under whose guidance he perfected his landscape technique. In 1880, in spite of the opposition he encountered from Renoir and Monet, who still regarded him as an amateur, he presented seven paintings and a bust at the fifth Impressionist exhibition. His presence at this official meeting filled him with enthusiasm, and his works attracted many favorable comments. The following year he presented eight paintings and two sculptures and, for the first time, he came to the attention of the art critics; however, the 12 works he showed in 1882 attracted many negative reviews, and were seen as less innovative than his earlier paintings.

In the meantime, his wife Mette witnessed with growing concern the way in which Gauguin's hobby was turning into an all-consuming passion. She tried to remind him of his duties as a husband and father, but her complaints had the opposite effect, and drove him away for good.

■ *The Sculptor Aubé and a Child*, 1882, Musée du Petit Palais, Paris. The composition of this portrait is unusual. The painting presents two images, which are unrelated except for the china vase at the centre.

■ *Garden in the Snow*, 1879, Szépmüvészeti Mùzeum, Budapest. An Impressionist concern with the changing effects of light on the landscape is evident in this work.

■ *Portrait of Valérie Roumy*, 1880, Ny Carlsberg Glyptothek, Copenhagen. This painted wooden medallion reflects the influence of Degas' ballerinas.

■ *View of Vaugirard*, 1879, Smith College Museum of Art, Northampton, Massachusetts. In this work the brushstrokes are less regular than in his earlier paintings, and the colors lighter and more intense. The realistic setting is reminiscent of Pissarro.

■ *Garden at Vaugirard*, 1881, Ny Carlsberg Glyptothek, Copenhagen. Here, Gauguin portrays his wife Mette with their children in the garden of rue Carcel, in the district of Vaugirard. In the background is the Romanesque-style church of Saint-Lambert. The short and irregular brushstrokes are clearly influenced by Pissarro.

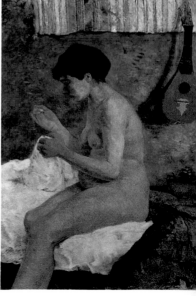

■ *Suzanne Sewing*, 1880, Ny Carlsberg Glyptothek, Copenhagen. Shown in 1881, at the sixth Impressionist exhibition, this work portrays the children's nanny. It was the first painting to attract the favorable comments of the critics, in particular of Huysmans, who praised its intensity and realism. Degas also admired it.

Impressionism

Impressionism was born in the 1860s. The first group was formed by Monet, Renoir, Bazille, and Sisley, fellow students of Gleyre, who in 1862 began to meet at the Café Guerbois and other Parisian cafés to discuss their discontent with academic teaching. They were joined by the artists Pissarro, Cézanne, and Guillaumin and critics Théodore Duret and Georges Rivière. In 1874, spurred on by the rejection of their works by the Salon, the group organized its first official exhibition in the Paris studio of the photographer Nadar. The term "Impressionism" was first used on this occasion when the journalist Louis Leroy made a sarcastic attack on one of Monet's paintings, *Impression: Sunrise*. The seven exhibitions that followed were received with increasing acceptance by the critics, and witnessed an ever-growing public success. Independently of their individual style, all the Impressionists shared a desire to abandon the traditional teachings of the Académie. Eager to learn the lesson of naturalists like Courbet, Corot, and Delacroix, they left their studios behind and painted *en plein air*. The outline lost importance as color became the main element used to express and communicate emotions and feelings.

■ Pierre Auguste Renoir, *The Moulin de la Galette*, 1876, Musée d'Orsay, Paris. Although he was a good landscape painter, Renoir best expressed his art in portraits of sensual, voluptuous women in the tradition of Titian and Rubens and in representations of everyday scenes. This famous painting portrays a cheerful dancing party in Montmartre.

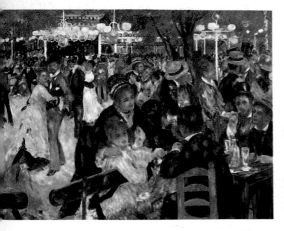

■ Edgar Degas, *The Dance Class*, 1873–75, Musée d'Orsay, Paris. Degas was intrigued by the world of the theater, especially by ballerinas, whom he portrayed with grace and elegance. He seldom represented them while dancing, however, preferring to show a glimpse of an intimate moment of their life behind the scenes.

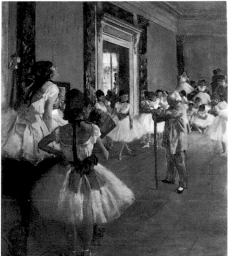

■ Claude Monet, *Poppy Field*, 1873, Musée d'Orsay, Paris. Monet uses the people in this work as a device to draw the eye to the cluster of red poppies.

■ Paul Cézanne, *A Modern Olympia*, 1873–74, Musée d'Orsay, Paris. Cézanne showed this work, a parody of Manet's *Olympia,* at the first Impressionist exhibition. The onlooker is a self-portrait.

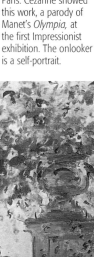

■ Edouard Manet, *Le Déjeuner sur l'Herbe*, 1863, Musée d'Orsay, Paris. Rejected by the Salon, this painting was shown at the Salon des Refusés. The critics and the public were shocked by the many technical innovations in this work.

Interior, Rue Carcel

MASTERPIECES

Housed in the Nasjonalgalleriet in Oslo, this 1881 work portrays Gauguin's home in Paris. Placing the flowers in the foreground, and leaving the characters in the background was a brave and noncomformist choice.

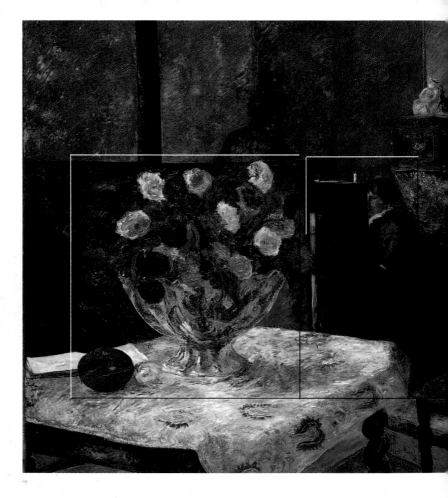

■ The influence of Gauguin's Realist and Naturalist mentors is demonstrated by the careful and conventional representation of small details such as the clogs.

■ In 1882, this painting was shown at the seventh Impressionist exhibition, where it attracted some critical interest. Gauguin tried to transmit his love for painting to his wife, but clashed against Mette's manipulative, cold personality. In his letters he often scolded her for her utter disinterest in anything artistic, and for her "silly concerns about money, pretty dresses, and neighborhood gossip".

■ As in many other still lifes of this period, the brushstrokes are short and thick, while the colors are melted together to increase the impression of depth.

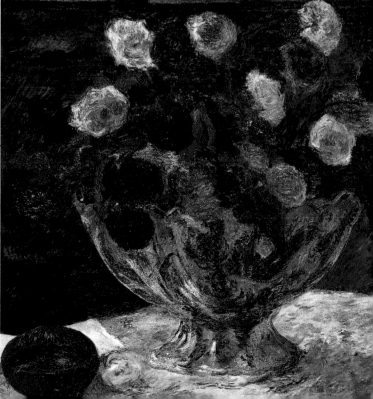

1882–85: Rouen and Copenhagen

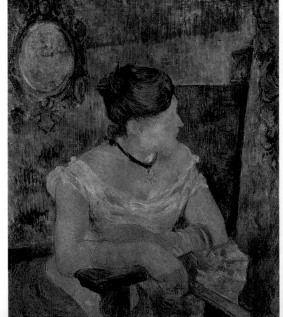

As a consequence of the collapse of the Union Générale in 1883, Gauguin lost his job and decided, against his wife's advice, to devote himself to painting on a full-time basis. In November they moved to Rouen, in Normandy, partly because life was not so expensive as in Paris, and partly to follow Pissarro's example. The new environment, however, did not respond favorably to Gauguin's innovative art, and success eluded him. Unable to sell his paintings, he soon exhausted his savings. After eight months, Mette, frustrated by her husband's inability to provide a decent living for his family, returned with their children to her parents' home in Copenhagen. Paul followed her, expecting to find an environment more receptive to his art, but he was deluding himself: an exhibition organized by the Society of the Friends of the Arts, went virtually unnoticed and closed after only five days. He found a job as a salesman but, made bitter by his failure, Gauguin decided to return to France, and leave his family behind.

■ This is one of the last pictures of Gauguin and his wife, taken in 1885 in Copenhagen in their house in Gammel Kongevej. Mette's family did not approve of Gauguin, preferring his brother-in-law Fritz Thaulow, a mediocre, but successful painter.

■ *Portrait of Mette in a Gown*, 1884, Nasjonalgalleriet, Oslo. Distinctly Impressionist in style, this painting conveys a feeling of coldness and detachment.

■ *Rouen: The Blue Rooftops*, 1884, Private Collection, Winterthur. The environment in Rouen was hostile to Gauguin's art.

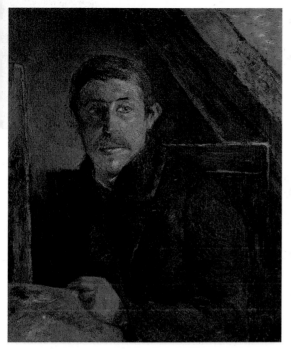

■ *Self-Portrait in front of an Easel*, 1885, Private Collection. Painted in Copenhagen, this self-portrait shows the artist deep in thought, perhaps contemplating his escape to France.

■ *Still Life with a Mandolin*, 1885, Musée d'Orsay, Paris. Two elements in this work had a deep meaning for Gauguin: the mandolin he used to play, and the picture by Pissarro or possibly Guillaumin in the background.

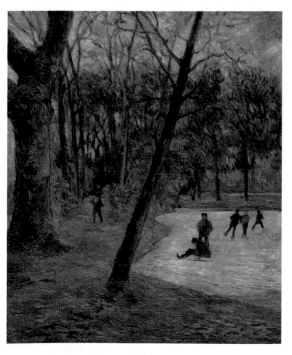

■ *Skaters in the Park of Frederiksberg*, 1884, Ny Carlsberg Glyptothek, Copenhagen. "Right now I feel low on courage and resources… Each day I wonder whether I should go to the barn and put a rope around my neck. Painting is the only thing that keeps me alive."

France: the Third Republic

■ Pierre Joseph Proudhon was a theorist of French socialism. He opposed the idea of private property, and fought for an egalitarian society that would respect the freedom and the rights of its citizens.

On September 1, 1870, after defeating the French at Sedan, the Prussians besieged Paris. The city surrendered the following year, on January 28: France had to yield Alsace and a large part of Lorraine. Napoleon III's empire was followed by the Third Republic, but the political situation remained unstable. On March 18, Paris witnessed the first significant episode of class struggle: a popular uprising against the Thiers government expelled the regular troops and started the Commune. The official response was violent: 20,000 people were killed and, out of a further 13,000 convicted, 270 were sentenced to death and 7,500 to deportation. During the Assembly debate on constitutional laws, the republicans had to battle against the royalists, who wanted to restore the crown to the Bourbons. Although the situation settled in 1884, with Giulio Ferry's government, some political instability still threatened the country, especially following the introduction of the anticlerical laws to promote secularized education, and Ernest Boulanger's attempt in 1889 to repeat Napoleon III's coup. In the meantime the foreign policy was blossoming, supported by successful colonial expeditions in Africa (Congo and Tunisia) and Asia (Tonkin, Annam, and Laos).

■ Poet, novelist, and the greatest figure in French Romanticism, Victor Hugo was a committed political activist. An early supporter of Louis Philippe, he became a republican, and was exiled for 19 years after the coup of Napoleon III. During the Republic, he resumed his role as guide, and was greeted with honor and respect.

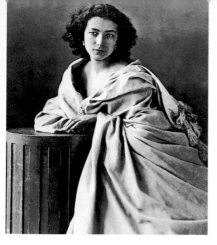

■ Born Henriette Rosine Bernard, Sarah Bernhardt (1844–1923), shown here in a photograph taken by Félix Nadar, was the most famous actress of the time. She made her début at the Comédie in 1872, and soon became popular by acting in both classic and contemporary works, such as the plays by Victorien Sardou.

■ *Napoleon III Captured*, Musée Carnavalet, Paris. At Sedan, Moltke's troops crushed Mac-Mahon's army: at least 100,000 French soldiers, including the Emperor himself, were made prisoners. On September 4, the Parisians led by Gambetta and Giulio Favre proclaimed the Republic.

■ The Church of the Sacre Coeur was built in 1876 on the hill of Montmartre, also known as "La Butte". Its funds raised with a national subscription, the church was consecrated in 1919. The architects, including Abadie and Magne, selected a compound style with Romanesque and Byzantine elements.

Socialism in France

Marx and Engel's Communist Manifesto, published in 1848, was a major influence on the rise of socialist ideas in France. The First International of Workers was established in 1864, and it eventually gave rise to the Paris Commune. In 1884, when freedom of association was restored, the labor movement split into different branches, such as Guesde's Marxists, Allemane and Brousse's Reformists, and Blanqui's Revolutionists. In 1892 the General Trade Union was created, and 1899 witnessed the birth of the Second International, which, a year later, adopted May 1 as Labor day. In 1905, thanks to pressures from the Marxists and Jean Jaures, the Unified Socialist Party became a reality.

1848–1885

Cows Drinking at the Trough

When Gauguin painted this picture in 1885 he had already developed his own unique style, and had undoubtedly concluded his long and patient period of apprenticeship. It is now housed in the Galleria d'Arte Moderna in Milan.

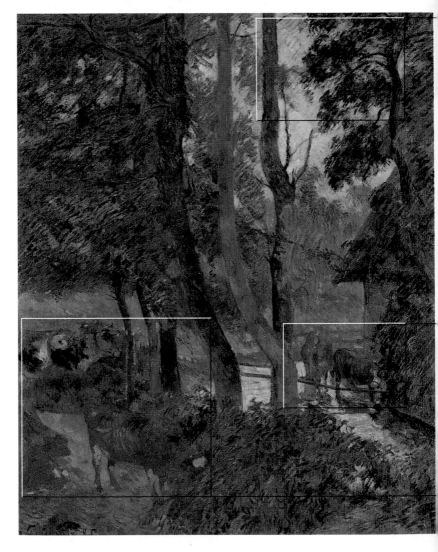

■ The scene is dominated by tree trunks. Along with the reflections in the water, the trunks divide the painting into two parts: the brighter side, lit by the sun, and the darker side in the shade. The rich, thick vegetation of the forest plays an important role within the picture, and anticipates the works Gauguin painted in Brittany and Polynesia.

■ The cows drinking placidly from the pool give the scene a sense of calm and serenity that is reminiscent of 17th-century Flemish paintings. Indeed, this work seems to have been partly inspired by that artistic current. The rendering of light reflected on water is remarkable.

■ Gauguin applies his colors with broad brushstrokes, preferring to focus on the scenic and decorative details, than on conveying a sense of depth. Despite the division in the sunlit and shaded areas, Gauguin presents a harmonious scene, devoid of sharp contrasts. The presence of the animals is discreet and reassuring and still unrelated to the disturbing symbolism of his Tahitian paintings.

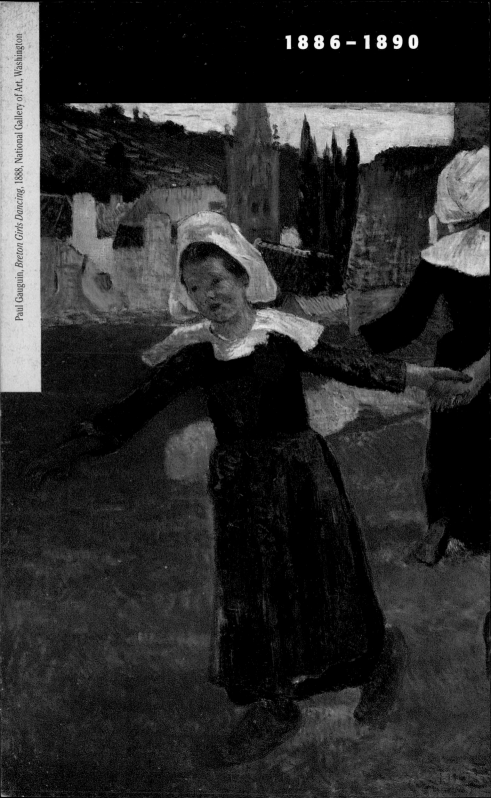

1886–1890

Paul Gauguin, *Breton Girls Dancing*, 1888, National Gallery of Art, Washington

Brittany and other places

1885–86: from Paris to Pont-Aven

In June 1885 Gauguin left his family in Denmark, and returned to Paris with his son Clovis, then six years old. At first he was a guest of Schuffenecker, then of a widow, Mère Fourel; finally, he left Clovis with his sister Marie and joined Pissarro and Degas in Dieppe. However, he was in such an emotional turmoil that he fought with both artists. Back in Paris, he quickly ran out of money. When Clovis fell ill, he managed to sell two of his pictures and agreed to work as a bill poster for five francs a day. In May 1886 he took part in the eighth and last Impressionist exhibition and, two months later, finally had enough money to travel to Brittany, a journey he had been planning for months. Settled in Pont-Aven, he lived at the inn of Marie-Jeanne Gloanec. Here he met various artists, including Charles Laval, who became his most devoted disciple, and the 18-year-old Émile Bernard. He painted all day long, and spent his evenings in lengthy conversations that he always dominated thanks to his strong, decisive personality.

■ At this time, Pont-Aven had 1,500 inhabitants, two hotels, and the Gloanec inn. The latter was humble but welcoming, relatively inexpensive at 75 francs a month full board, and it provided excellent food.

■ *Breton Boys Bathing*, 1886, Museum of Art, Hiroshima. The presence of nude figures in a landscape was a recurrent theme in Impressionist works, especially those by Cézanne. In this painting, Gauguin offers his own interpretation of the subject.

■ Gauguin was attracted by Brittany partly because this area had maintained a strong link with its past and traditions.

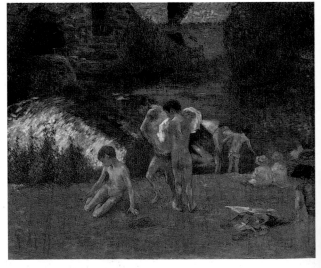

■ *Self-portrait*, 1886,
National Gallery of Art,
Washington. In this
work Gauguin proudly
wears an embroidered
Breton waistcoat. The
painting was originally
dedicated to Laval.
Following the collapse
of their relationship,
however, Gauguin
dedicated it to Eugène
Carrière. He hated Paris,
and was glad to be in
Brittany; in a letter to
Schuffenecker he wrote,
"You prefer Paris; I, on
the other hand, love the
country, where I find the
wild and the primitive".

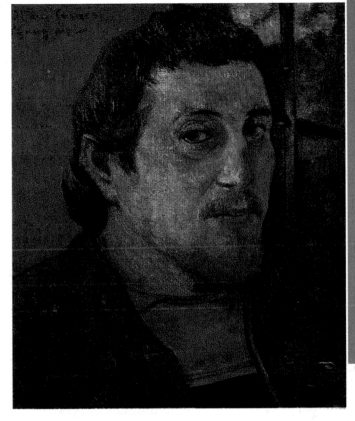

■ *Portrait of a Woman*,
1886, Bridgestone
Museum of Art, Tokyo.
On the right of this
elegant and delicate
portrait is one of
Gauguin's china
vases, sadly now lost.
It also appears in *Still
Life with a Profile of
Laval* and is mentioned
in a letter to his wife.

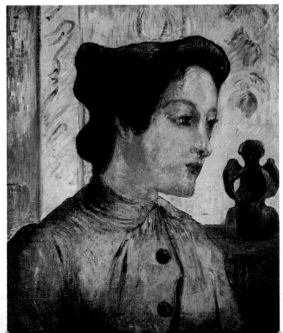

Why Brittany?

Gauguin's move to Pont-Aven,
recommended by the Breton
painter Jobbé-Duval, did not
happen by chance; for over twenty
years, this characteristic port in
Finistère had attracted many
artists, especially foreign ones.
Gauguin had also been influenced
by *Voyage en Bretagne* by Flaubert.
Therefore, moving there was not a
temporary solution to his money
problems, but the search for a
land still tied to its popular
traditions, where he could find
new sources of inspiration.
Brittany appeared to Gauguin like
a wild, mysterious land in which
myths and legends still thrived.

Four Breton Women

The unusual approach to the subject and stylistic innovations, such as the decorative use of the white bonnets and the colorful skirts, make this Gauguin's most important work of this period (1886, Neue Pinakothek, Munich).

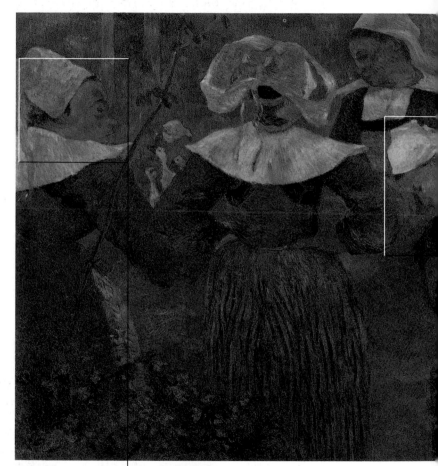

■ This painting shows an unmistakable shift in Gauguin's work toward Synthetism. The clearly marked contours of the women's headdresses, faces, and collars would later develop into a preference for heavily outlined areas of pure color. This *cloisonné* style, developed in collaboration with Émile Bernard, was not easily understood or accepted, but it came to form the basis of many Art Nouveau paintings.

■ The presence of so many artists had not changed the lifestyle of the people of Pont-Aven; indeed, they had learnt to pose unaffectedly, finding this activity both pleasant and profitable.

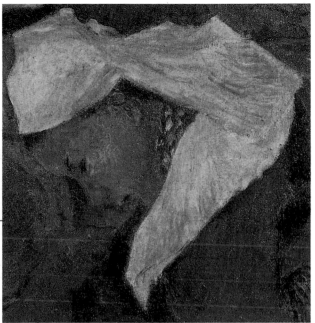

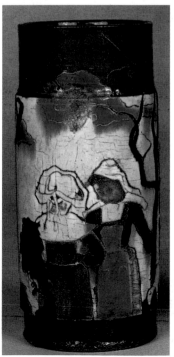

■ *Young Breton Girl*, 1888, Private Collection. The artist preferred to portray the simple, raw beauty of Breton girls to the polished sophistication of Parisian models.

■ Vase decorated with a Breton scene, 1886–87, Musées Royaux d'Arts et d'Histoire, Brussels. The design on this vase was created by filling the engraved outlines with colored enamel.

1887: the first trip to Martinique

On April 10, 1887, accompanied by Charles Laval, Gauguin decided to leave France, where he felt his career had no opportunity to develop, to "live like a savage" and work on Toboga, an island in the Gulf of Panama. He had been there twenty years earlier, and was hoping to get some help from his brother-in-law Uribe. However, upon his arrival in Colòn on April 30, Gauguin found the environment had changed in his absence and had become rather hostile; to make things worse, Laval contracted malaria. Disappointed and almost out of money, Gauguin was forced to work as a navvy for the excavation of the Panama Canal. In the first week of June, they moved to the nearby island of Martinique: after landing in Fort-de-France, they settled near St. Pierre, on the northwest coast of the island. Unfortunately, in July Gauguin himself fell victim to malaria, which manifested itself through serious dysenteric and hepatic disorders and he was forced to seek repatriation. Although ill and poor, he still managed to find the physical and mental energy to execute many sketches and paint a dozen canvases before his return. The Martinique pictures are significant in that they mark an definitive break with Impressionism.

■ Early in 1887 Gauguin wrote to Mette: "What I want most of all is to get out of Paris, which is a wilderness for the poor man. My reputation as an artist grows by the day, yet at times I cannot find anything to eat for three days in a row, with serious consequences for my health, but most of all for my *energy*".

■ *Caribbean Woman*, 1889, Private Collection. Impressed by their imposing beauty, Gauguin often painted Martinican women.

■ Martinique is an island in the Lesser Antilles. An overseas French region, in the 19th century it was seen as a paradise on earth.

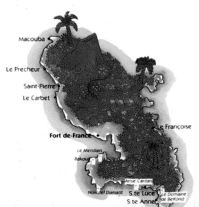

■ *By the Sea*, 1887, Ny Carlsberg Glyptothek, Copenhagen. Gauguin wrote to Schuffenecker: "Not far from us is a sandy beach and the sea where we swim. And everywhere we look there are palm and other fruit trees that are ideal for a landscape artist".

■ *By the Sea*, 1887, Private Collection, Paris. Indifferent to the shocked and slightly racist reactions of the white inhabitants of the island, Gauguin deliberately chose to live with the locals.

■ *Fruit Picking*, 1887, Van Gogh Museum, Amsterdam. Theo van Gogh was so impressed by this work that he purchased it for himself. It is one of the best works of the Martinican period.

Coming and Going

About this 1887 painting Gauguin said: "What I find so bewitching are the figures, and every day here there is a continual coming and going of black women". Today this work is part of the Thyssen-Bornemisza Collection in Madrid.

■ Gauguin's interest in the inhabitants of the island is not superficial: he observes them while they work in the fields, during their rest, and while they celebrate. He studies their clothing and habits; he pays attention to the way they speak, the way they move their hands and their bodies, and tries hard to understand their thoughts in order to know them better, and to be considered one of them, not an outsider.

■ Upon his return to France, Gauguin showed his Martinican paintings with pride. In January 1888 the critic Félix Fénéon reviewed them in a long and flattering article, writing: "Imbued with a barbaric and melancholic feeling, with little atmosphere, colored with diagonal brushstrokes falling from the right to the left, these superb paintings represent the synthesis of Mr Paul Gauguin's opus."

■ The main subject of the Martinican paintings is the nature of the island: a luxuriant and wild nature that impressed and moved Gauguin, and made him feel part of this paradise. In spite of his poor health and financial difficulties, his painting had never been so full of light and vitality.

■ *Tropical Vegetation*, 1887, National Gallery of Scotland, Edinburgh. In the background of the painting is the bay of St. Pierre, with the volcano Pelée. Gauguin has deliberately hidden the town behind rich vegetation, in order to give the impression of a paradise, untouched by man.

1888: Pont-Aven

Welcomed by Schuffenecker, in the middle of November 1887 Gauguin was in Paris again. Here he met Theo van Gogh, director of the Boussod Gallery; Valadon, the first art dealer to take an active interest in his work; and Theo's brother Vincent. Disappointed by his failure as a preacher, the latter was ready to devote his life to painting. Encouraged by the sale of some of his works by Theo van Gogh, on January 26, 1888 Gauguin, still plagued by a stomach ailment, returned to Pont-Aven, where he had booked a room at the Gloanec inn. During this period he worked alongside Émile Bernard to develop a manner of painting known as Synthetism. This style celebrated simplified reality and the synthesis that occurs when an artist does not paint from life, but from memory colored by emotion. Reacting to the naturalism of the Impressionists, the point of Synthetism was to "paint an object the way the imagination perceived it, not as it really was". The artist could then disregard the shapes and colors of reality, and be free to express their effects on his emotions. Synthetism was influential on the Nabis.

■ This photo of Gauguin in Pont-Aven was taken in 1888. In the summer of the same year, Gauguin fell in love with Bernard's younger sister Madeleine, who preferred his student and friend Charles Laval.

■ *Still Life Fête Gloanec*, 1888, Musée des Beaux-Arts, Orléans. Gauguin gave this painting to Marie-Jeanne Gloanec on August 15. In order to overcome her mistrust, he signed it "Madeleine B.", the name of Bernard's sister, and told her it was "the work of an amateur".

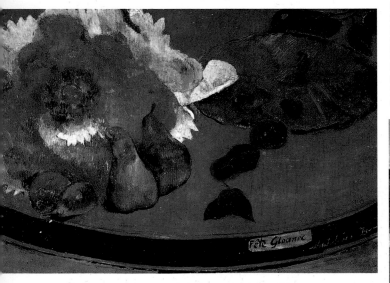

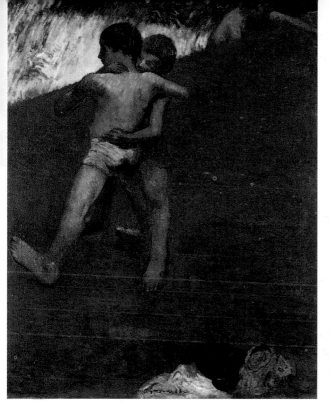

■ *Children Wrestling*, 1888, Josefowitz Collection, Lausanne. "I have just finished a Breton wrestling scene that you will certainly like… Two young boys in blue and vermilion shorts. A third in the upper right-hand corner emerging from the water. Green meadow. Pure veronese fading into chrome yellow: the surface unrefined, as in Japanese *crèpons*."

■ *Still Life with Three Puppies*, 1888, The Museum of Modern Art, New York. Vincent van Gogh mentioned in a letter to Theo that Gauguin wanted to focus on "childlike art". His models were Japanese prints and English children's books.

■ *Breton Peasant with Pigs*, 1888, Mrs. Lucille Ellis Simon Collection, Los Angeles. This is a view of Pont-Aven, with St. Margaret's hill in the background. Although the composition is reminiscent of the Impressionists, the use of bold, bright colors is clearly inspired by Martinique.

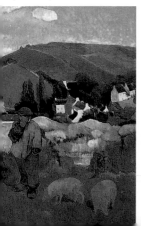

Émile Bernard

Émile Bernard was born in Lille on April 28, 1868: from a young age he showed an interest in painting, and was a student of Fernand Cormon and a friend to Toulouse-Lautrec. A uniquely talented artist, he had much in common with the Impressionists. During a journey to Brittany in 1886 he met Gauguin; upon his return to Paris, he also made the acquaintance of van Gogh, with whom he exhibited in 1887. His role was vital: he acted as a buffer between the difficult and strong personalities of his two friends. Bernard portrayed the subjects of his paintings as large masses of bright colors framed by darker outlines, a style known as Cloisonnism that was highly influential on van Gogh and Gauguin. After 1891 he continued to paint in Pont-Aven, although he travelled to both Italy and Egypt on a regular basis. After marrying a Lebanese woman, Henenah Saati, he lived in Egypt for ten years, and had five children. In 1901, Bernard fell in love with poet Paul Fort's sister, Andrée, and left Egypt and his wife. He continued to travel between Brittany and Venice until his death in Paris on April 16, 1941.

■ Émile Bernard, *Breton Women Going to Church*, 1892, Private Collection. The female figures are merely decorative motifs: even their facial features are reduced to simple lines.

■ Émile Bernard, *The Four Seasons*, detail, 1891, Private Collection. This screen was commissioned by the Belgian Eugène Boch.

■ Émile Bernard, *Breton Women with Umbrellas*, detail, 1892, Private Collection. The sun has the effect of intensifying the color in this work, but the absence of shadow gives a sense of unreality.

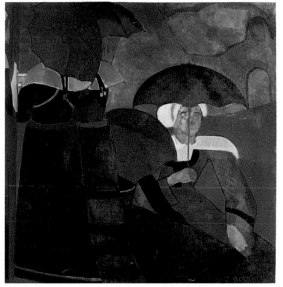

■ Émile Bernard, *Rue Rose at Pont-Aven*, 1892, Didier Imbert Fine Art, Paris. Rue Rose was a busy thoroughfare. However, Bernard painted it as a deserted street, as if to indicate his loneliness after Gauguin's departure for Tahiti.

■ Émile Bernard, *Two Bathers under a Tree*, detail, 1889, Galerie Daniel Malingue, Paris. Bernard also handled Cézanne's traditional theme of the bathers. In this work, the woman's body stands out against the green meadow. The artist used thick, heavy brushstrokes to absorb and reflect the light.

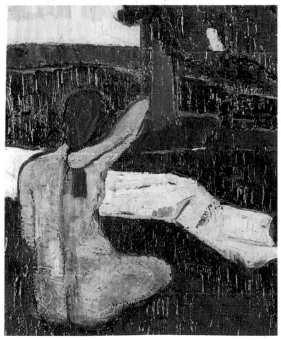

1886–1890

The Vision after the Sermon

Gauguin offered this canvas as a gift to the parish priest of Nizon, but he rejected it. Completed in 1888, this landmark work shows Gauguin's shift from Impressionism to Symbolism. It is kept in the National Gallery of Scotland, Edinburgh.

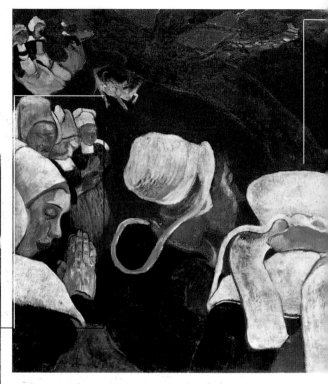

■ Gauguin wrote to Vincent van Gogh about this painting: "I believe I have attained in these figures a great rustic and superstitious simplicity. The whole is very severe". Shunning traditional ideas about perspective, Gauguin uses flat areas of unmodulated color framed by heavy blue-black outlines.

■ The positions of Jacob and the angel were inspired by a print by the Japanese artist Hokusai. In the Brittany paintings, and even more so in the Polynesian works, Gauguin tried to portray expressions of popular religiosity, the mixture of faith and superstition that colors the beliefs of simple people. For Gauguin's characters, the truth is to be emotionally felt, not just rationally understood.

■ With his letter to van Gogh, Gauguin included a sketch of the painting, hinting at the colors he would use. "I believe that the landscape and the fight only exist in the imagination of the people praying after the sermon, which is why there is a contrast between the people, who are natural, and the struggle going on in a landscape which is non-natural and out of proportion".

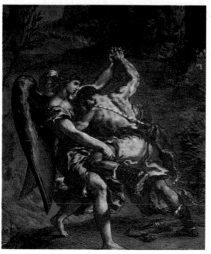

■ Eugène Delacroix, *The Struggle of Jacob and the Angel*, 1860, Church of Saint-Sulpice, Chapel of the Holy Angels, Paris. This painting represents a passage from Genesis (32: 23–31), in which the fight is seen as symbolic of the turmoil within the Christian soul. A reference to this episode also appears in Victor Hugo's *Les Misérables*. Gauguin had recently read the novel, and had identified with its protagonist (see pp. 50–51).

The Pont-Aven School

Although brief, Gauguin's stay in Brittany was extremely influential: not only did it radically alter the traditional way of painting, it also gave rise to what became known as "the Pont-Aven School". When he first moved there, Gauguin had already developed a reputation as an exponent of Impressionism through his exhibitions; soon, however, other artists realized that he was distancing itself from that school, to become more representative of Synthetism. In September 1888 Paul Sérusier arrived in Pont-Aven: he had been a student at the Académie Julian in Paris, and he asked Gauguin for some lessons. Along with Bernard, who considered himself the founder of this style, Sérusier was the most sincere believer in the effectiveness of Synthetism. Soon other painters joined him, and they formed a coterie, in which they exchanged theoretical and creative ideas. The school included among others the French Charles Laval, Ernest Chamaillard, and Ferdinand du Puigaudeau, the Danish Mogens Ballin, the Dutch Jan Verkade and Jacob Meyer de Haan, the Swiss Cuno Amiet, and the English Robert Bevan.

■ A specialist in still life and a student of Gauguin, Jacob Meyer de Haan was also his patron, since he used to pay for Gauguin's room in exchange for art lessons. The warm colors used in this *Still Life with a Blue Pitcher and Pears* (1890, Private Collection) are similar to those used in 17th-century Flemish art.

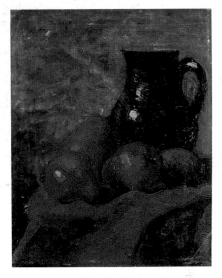

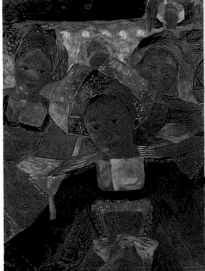

■ Ferdinand du Puigaudeau, *Breton Girls with Lanterns*, detail, 1896, Didier Imbert Fine Art, Paris. Lit by Chinese lanterns under a black sky, these Breton girls dance gaily during one of the many festivals organized to enliven summer evenings. The lace bonnets appear to be delicately transparent.

■ Charles Laval,
The Fence, c.1890,
Private Collection.
In an 1889 painting,
Gauguin portrayed
the same subject –
Kernévénas' farm at
Le Pouldu – from the
same viewpoint.

■ Paul Sérusier,
Praying Breton Girl, 1892,
Galerie Daniel Malingue,
Paris. Sérusier executed
this work on cardboard,
the color of which was
deliberately retained in
the face and hands.

■ Mogens Ballin,
Breton Landscape,
detail, 1892, Private
Collection. During
Jan Verkade's stay in
Saint-Nolff, Ballin
visited several times.
He considered the
landscapes in the
local area to be
breathtakingly moving.

1888: in Arles with van Gogh

On February 20, 1888, Vincent van Gogh moved to Arles, in Provence. In May, he wrote to Gauguin suggesting he should go and paint with him. For nine weeks they lived and worked together, creating about 20 pictures each. They used to spend the days sketching and painting in the country *en plein air*, and the evenings comparing their efforts, arguing about art, and trying to convince each other of the validity of their theories. It was a volatile situation, and the irreconcilable differences in their personalities finally drove them apart. The fear of losing his friend and the thought of having to be alone again contributed to van Gogh growing unhealthily jealous. On December 23, after yet another row, Gauguin decided to leave.

In desperation, van Gogh turned to self-abuse and, during the night, he cut off part of his left ear, which he then gave to Rachel, a local prostitute. Shocked by his friend's violent reaction, Gauguin returned to Paris, determined never to see van Gogh again.

■ *Old Women at Arles*, 1888, The Art Institute of Chicago. Clearly influenced by Cloisonnism, this painting is especially remarkable for the reserved dignity of the four women, their solemn procession, and thoughtful, almost theatrical, gestures.

■ *Farm at Arles*, 1888, Museum of Art, Indianapolis. In the early paintings executed in Arles, Gauguin portrayed the local landscape and the toil of the farmers.

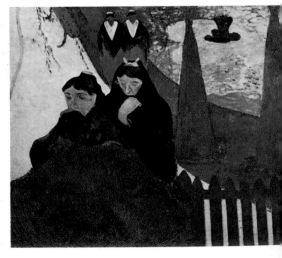

■ *Van Gogh Painting Sunflowers*, 1888, Van Gogh Museum, Amsterdam. With a few cruel details, Gauguin highlighted the physical signs of his friend's mental instability. "This is me gone mad", commented van Gogh.

■ *The Alyscamps*, 1888, Musée d'Orsay, Paris. The Christian necropolis of Alyscamps, here portrayed with the dome of the Saint-Honorat chapel in the background, was a favorite haunt of the two artists, and it appears to have been the inspiration behind many paintings. The style of this work and the use of bright colors are the direct result of the "synthetist" influence Gauguin felt in Brittany.

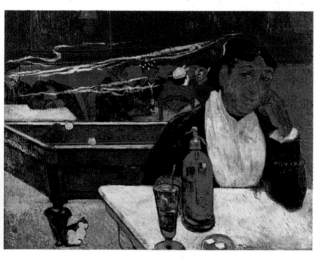

■ *At the Café*, 1888, Pushkin Museum, Moscow. This painting was born as a challenge and a homage to van Gogh. The subject is not typical of Gauguin, and he handled it by investing the work with reminders of Cézanne.

We shall always be friends

The letters exchanged between Gauguin and the van Gogh brothers reveal the depth of their artistic and emotional bond. Many of these letters have now been published, but they still represent only a small percentage of the actual written correspondence between the three friends. Although it is hard to establish an accurate chronological order, these letters are vitally important in our attempts to understand the personalities of the artists, their flaws and virtues, and the development of their art.

Les Misérables

Executed in 1888, this painting was a present for van Gogh, who had often asked Gauguin and the other artists at Pont-Aven to send him their self-portraits. Today it is housed in the Van Gogh Museum in Amsterdam.

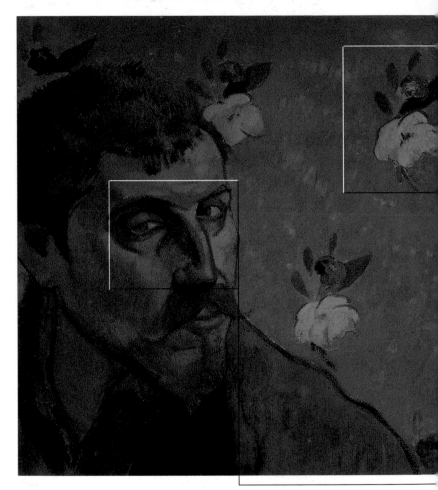

■ Gauguin's self-portrait was influenced by the description of Jean Valjean, the protagonist of Victor Hugo's *Les Misérables*: like Valjean, Gauguin also felt persecuted by society.

■ On the wall behind Gauguin there is a small sketched portrait of Bernard who, in return, added a portrait of Gauguin in his own gift to Vincent. Van Gogh was grateful for the paintings and, although he confessed to Theo that he preferred Bernard's work, he thanked Gauguin by sending him his own *Self-Portrait*, now housed in the Fogg Art Museum in Cambridge, Massachusetts.

■ Gauguin explained in a letter to van Gogh that "the lines around my eyes and nose remind me of flowers on a Persian rug, and are influenced by abstract art and Symbolism; the feminine, childlike flowers in the background, on the other hand, indicate our artistic purity". Gauguin was already experimenting with some decorative effects that he would later use in the Polynesian works.

He wrote to Vincent: "Blood rushes to my face, and the colors around my eyes are similar to those you would see in a forge: this is to convey the burning lava flowing through my artistic soul".

1886–1890

Vincent van Gogh

■ Van Gogh, *Madame Ginoux*, 1890, Museu de Arte, São Paulo. By painting this lady in the same way in which Gauguin had portrayed her a few months earlier, van Gogh wanted to create a souvenir of the successful collaboration with his friend and, at the same time, express a wish for it to be re-established.

Vincent Willem van Gogh was born on March 30, 1853, in Groot Zundert, a village in Dutch Brabant. After leaving school, he found a clerical job in the Hague branch of Goupil, an international firm of art dealers. He worked here until 1876, then moved to England where he taught before becoming a lay preacher in a working-class community, a bookseller in Dordrecht, and again a preacher in Belgium. In October 1880, he enrolled at the Académie des Beaux-Arts in Brussels and started to paint in Nuenen, Antwerp, and Paris, where he met some of the Impressionists who exhibited their works in his brother Theo's gallery. The time he spent in Arles was his most prolific, but also the most emotionally strenuous. Here he discovered the light and colors of the Mediterranean and created some of his masterpieces, but he also witnessed the failure of his dreams and projects, in particular those involving an artistic union with Gauguin. After Gauguin's departure, van Gogh's mental health deteriorated and he was admitted into a nursing home in Saint-Rémy-de-Provence. On May 16, 1890, he moved to Paris with his brother, and three days later he went on to Auvers-sur-Oise, a small town that attracted many artists. His medication seemed to work, and he painted about 80 canvases in just over two months. But on July 27, 1890, he shot himself in the field where he used to paint. After three days of agony, Vincent passed away, aged 37. His brother Theo died six months later, on January 25.

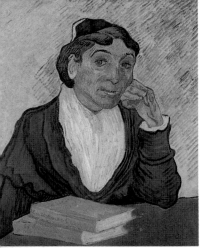

■ Van Gogh, *The Alyscamps*, 1888, Kröller-Müller Museum, Otterlo, Netherlands. The placement of the figures recalls Japanese prints.

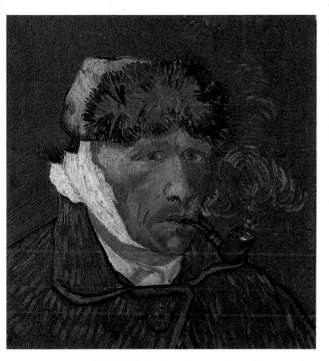

■ Van Gogh, *Self-Portrait*, 1889, Private Collection. He painted this work soon after being discharged from hospital. The bandage is on the right ear, while van Gogh had mutilated the left one: this proves that Vincent was painting in front of a mirror.

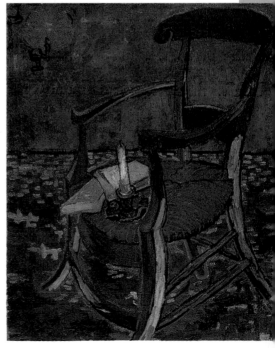

■ Van Gogh, *Gauguin's Armchair*, 1888, Van Gogh Museum, Amsterdam. Van Gogh never recovered from the departure of Gauguin. Here he tried to convey the void this episode left in his life: it was a desperate cry for help that revealed the profound anxiety that was to lead him to suicide.

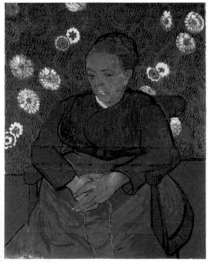

■ Van Gogh, *Portrait of Augustine Roulin*, 1889, Stedelijk Museum, Amsterdam. "I believe that if someone placed that painting in a boat of fishermen, even Icelandic ones, some of them would be able to hear within it the voice of a woman singing a lullaby".

1889–90:
Le Pouldu

In February 1889 Gauguin went to Pont-Aven for the third time. In May he visited Paris to exhibit with the Impressionists and the Synthetists in Volpini's café. After returning to Pont-Aven, he became annoyed at the constant stream of tourists, and at the end of June he and Sérusier moved to the nearby town of Le Pouldu. At first they stayed at the Hotel Destais, then at Marie Henry's Buvette de la Plage, where Meyer de Haan and other painters joined them. In October of the same year Gauguin and de Haan decorated the dining room of the boarding house in which they were staying with frescoes and paintings. He was in Le Pouldu when, in June 1890, he received the news of Vincent van Gogh's death. He sketched and painted the wild, dramatic landscapes around the area with intense passion. He still could not sell many paintings, however, and the situation was made worse by the death of Theo van Gogh. When his family stopped sending money for the rent, de Haan was forced to return to Holland. Soon after, on November 7, 1890, Gauguin moved to Paris to spend the winter there.

■ This photo portrays Gauguin with two of his children, Emile and Aline. In March 1891, before going to Tahiti, he visited his family in Copenhagen: it was the last time he saw them.

■ *Schuffenecker's Family*, 1889, Musée d'Orsay, Paris. In this rather unflattering portrait of his friend's family, Gauguin successfully mixed Impressionist elements with the Synthetist style he was developing at about this time.

■ Gauguin never lost touch with his wife, here photographed with their five children in 1889. In his letters he told her about his development as an artist and his plans for the future.

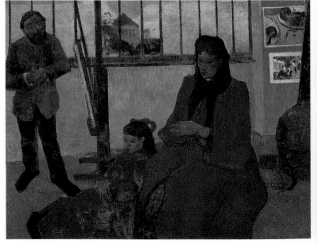

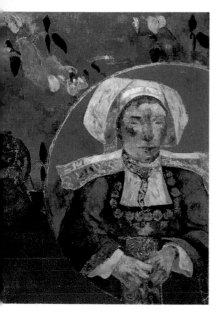

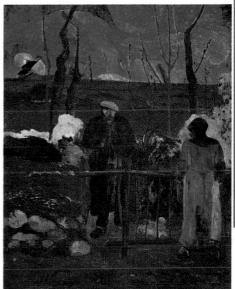

■ *La Belle Angèle*, 1889, Musée d'Orsay, Paris. Gauguin was extremely satisfied with this painting and convinced that "never had a portrait been as successful as this". The model was Angèle Satre, wife of an important man in Pont-Aven. She was offended by the results and rejected the picture, in which she felt she had been made to look ugly and ridiculous. Two years later Degas, who greatly admired this painting, purchased it for himself.

■ *Christ in the Garden of Olives*, 1889, Norton Gallery of Art, West Palm Beach. In this work Gauguin portrayed himself as Jesus in an attempt to convey his own spiritual restlessness and tormented soul.

■ *Bonjour, Monsieur Gauguin*, 1889, Národní Galerie, Prague. When he arrived in Le Pouldu, the 20-year-old André Gide was impressed by the paintings in Marie Henry's boarding house, especially this one.

Synthetism

Although the official creator of Synthetism, or Cloisonnism, was Bernard, Gauguin was its greatest and most ingenious exponent. The shapes on the canvas were no longer meant to portray reality, but the impression left on the memory by reality. The artist could forego the rules of perspective, tone, shading, and chiaroscuro, and just apply the color on a flat surface, delimiting it with thick contour lines. This style paved the way for Expressive Abstraction.

The Loss of Virginity

Imbued with literary and pictorial references, from Manet's *Olympia* to Holbein's *Dead Christ*, this painting became the quintessential example of Symbolism. Painted in 1890–91, it is now in the Chrysler Museum in Norfolk.

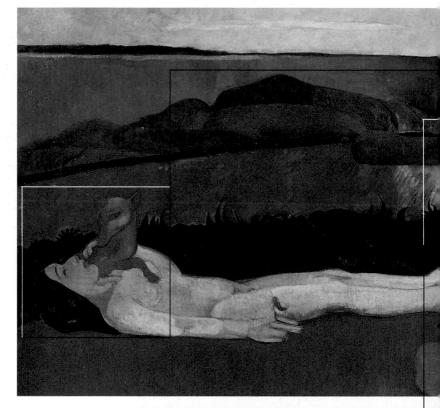

■ In the background, a bridal procession moves forward in the familiar landscape of Le Pouldu. The countryside is recreated as wide masses of colors limited by horizontal black marks. The thick outlines separate the cold shades of blue from the green and the purple-brown, and help to create a dreamlike atmosphere.

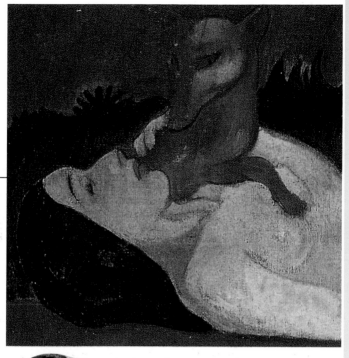

■ *Lewdness*, 1890, Willumusens Museum, Frederikssund. The first version of this statuette was made out of clay; when it broke, Gauguin recreated it in oak and pine. At the girl's feet is a fox, the artist's symbolic representation of perversity. While the Impressionists wanted to celebrate the beauty of nature, Gauguin preferred to look inward and explore the subconscious mind. His works are the creative expression of his anxiety, fears, and imaginary visions.

■ This painting is also known as *Spring Awakening*. The model is Juliette Huet, a young milliner who had been introduced to Gauguin by Daniel de Monfreid, and who had become his lover for a few months. The position of the girl is reminiscent of Bernard's painting, *Madeleine in the Bois d'Amour*. In her right hand she holds a red flower, and with the left hand she strokes a fox. The animal rests one of his paws on the girl's breast in a subtly erotic fashion.

1886–1890

Symbolist art

S ymbolist artists were the forerunners of the Surrealists. Inspired by the art of Edgar Allan Poe, Baudelaire, Flaubert, Wagner, and Burne Jones, they never acknowledged themselves as or gathered into a distinct cultural movement, nor did they adopt the same style or technique. Indeed, the term "symbolism" has only recently been coined by critics to indicate some unifying elements in the works of several painters with different artistic backgrounds and theories. This new current developed in France at the end of the 19th century, just as the Decadent style was flourishing. The novel *A rebours*, written by Huysmans in 1884, mentioned works by Moreau and Bresdin and celebrated their ability to overcome the rigors of Naturalism and represent a deeper spiritual level. Bergson's *Essais sur les données immédiates de la conscience* offered philosophical support to this new aesthetic theory, which also received many reviews in print. The exhibition of works by Gauguin and Bernard at Volpini's café in 1889 was an important step in the development of Symbolist painting, and its influence was felt until the early 1990s.

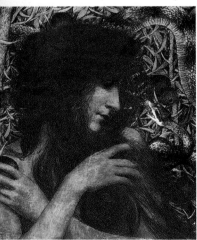

■ Pierre Puvis de Chavannes, *The Poor Fisherman*, 1881, Musée d'Orsay, Paris. Seen as a quintessential Symbolist painting, this work was purchased by the French government in 1887 and exhibited at the Musée du Luxembourg, where it was admired by a generation of young artists.

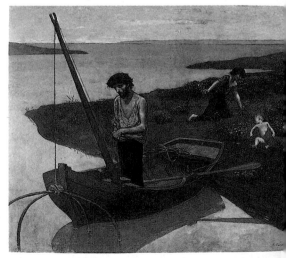

58

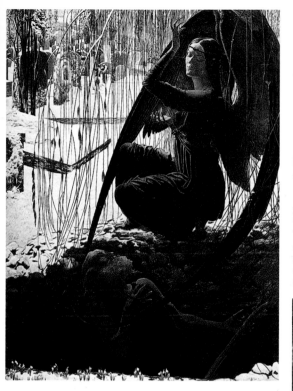

■ Carlos Schwabe,
*Death and the
Gravedigger*, 1895–1900,
Musée du Louvre, Paris.
German-born, Schwabe
worked mostly in
Switzerland. He was
compared to Dürer for
his mystic, visionary
images and his tragic
interpretation of death.

■ Odilon Redon,
Portrait of Gauguin,
1904, Musée du Louvre,
Paris. Redon was a
student of Corot and a
friend of Gauguin and
the Nabis. His incisive
and highly original
style made him one
of the major exponents
of Symbolism.

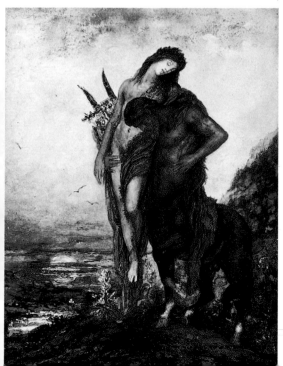

■ Gustave Moreau,
*The Poet and the
Centaur*, c.1870, Musée
Moreau, Paris. The last
great Decadent artist,
Moreau was heavily
influenced by the
Romantic tradition, and
created many intense,
visionary paintings.

Pottery and wooden sculptures

■ Vase in the form of a woman, 1889, Museum of Art, Dallas. Schuffenecker's wife, represented here, was often unfriendly towards Gauguin, who returned the favor by portraying her with pointy ears, like a faun, and with a snake curled around her head.

In 1886, during the last Impressionist exhibition, Gauguin met the engraver Félix Bracquemond and Ernest Chaplet, a talented ceramicist who taught him how to work with enamelled grès (stoneware). Gauguin developed a passion for pottery, and in just over a year he produced in excess of fifty works. Later, he also experimented with wooden sculptures and bronze castings, which he handled with great expertise and remarkable imagination. In his sculptures he strove to express unusual, original forms and, although they were received positively by the critics, they were a little too extravagant for the public of the late 1800s: contrary to Gauguin's optimistic expectations, sales were disappointing. These works represent a fusion of many different elements, from pre-Colombian cultures and traditional Japanese art, to innovations introduced by the Arts and Crafts Movement and Neoclassical models. He was so proud of these works that he often inserted them in his paintings, for example his *Still Life with a Japanese Print* (1889, Museum of Modern Art, Teheran) or *Still Life with a Profile of Laval* (1886–87, Josefowitz Collection, Lausanne).

■ Vase with a Breton woman, 1886–87, Kunstindustrimuseet, Copenhagen. Gauguin was not concerned with the vase's function, and preferred, instead, to concentrate on the decorative elements, creating unusual and innovative shapes.

■ *Bust of M. de Haan*, 1889, National Gallery of Canada, Ottawa. Gauguin created this wooden sculpture for the dining room of Marie Henry's inn.

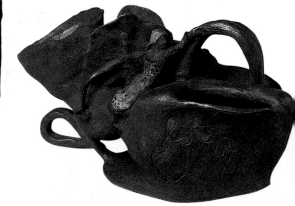

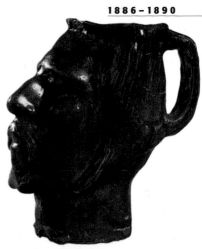

■ Vessel in the form of a head, Moche culture, Peru, The Metropolitan Museum of Art, New York. Gauguin's work was influenced by the pre-Colombian cultures he discovered in Lima and by the artefacts his mother had brought to France.

■ Vase as self-portrait, 1889, Kunstindustri-museet, Copenhagen. One of many vases in the shape of a head, this work is a fusion of popular tankards and anthropomorphic Peruvian pots.

■ *Nude Woman Standing*, 1890–91, Private Collection. Unlike Gauguin's "primitive" sculptures, this graceful statue is reminiscent of Degas' ballerinas.

■ *Eve and the Serpent*, 1889–90, Ny Carlsberg Glyptothek, Copenhagen. In this painted wood carving Gauguin mixes biblical images with Tahitian symbols.

Self-Portrait with Yellow Christ

In the background of this self-portrait, executed in 1889–90, Gauguin included two recent works which are loaded with symbolic meaning. *The Yellow Christ* and the tabacco jar embodied two sides of his nature: the spiritual and the wild.

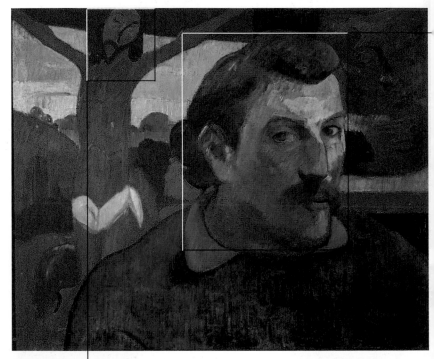

■ The figure of Christ in the background is even more stylized than in the original painting. The configuration of his face verges on the abstract.

■ *Portrait of Gauguin as a Grotesque Head*, 1889, Musée d'Orsay, Paris. This stoneware tobacco jar was meant as a token of love for Madeleine Bernard, but she did not accept it.

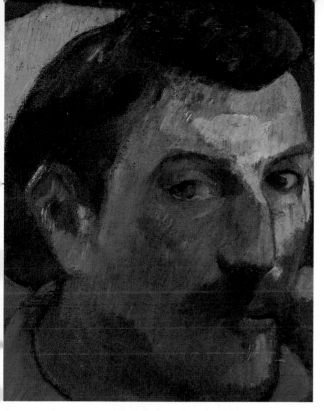

■ In most self-portraits Gauguin represented himself at a three-quarters angle: this pose allowed him to highlight his aquiline nose, square chin, large build and long, unkempt hair. The image he wanted to convey was that of a wild, untamed artist, unrestrained by social conventions. He appears as a powerful and strong-willed man determined to explore every avenue in order to see his ambitions become reality. At the same time, however, the searching look in his eyes reveals a struggle within.

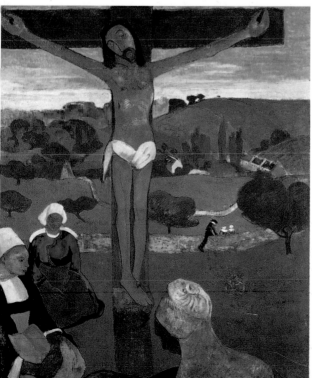

■ *The Yellow Christ*, 1889, Albright-Knox Art Gallery, Buffalo. This painting was inspired by a wooden crucifix in the chapel of Trémalo, near Pont-Aven. In the *Self-Portrait* it is back-to-front because Gauguin was painting in front of a mirror. This painting is an excellent example of Synthetism and Breton Primitivism, and it is reminiscent of the work of Bernard, who felt justifiably plagiarized.

The 1889 Exposition Universelle in Paris

■ Robert Delaunay, *The Red Tower*, 1928, Private Collection. Designed by Gustave Alexandre Eiffel, the Tower was built to celebrate the dawn of the industrial age at the 1889 Exposition Universelle. It took 17 months to complete, and is 300 metres (984 feet) high.

The 1889 Exposition Universelle started on May 6, and continued for exactly six months. In order to celebrate the centenary of the Revolution, Parisians were determined to organize a grandiose exhibition that would impress the whole world. They erected huge metal pavilions, such as the Machinery Gallery, no longer in existence, and the Eiffel Tower, which represented the triumph of iron architecture and became the symbol of the dawning industrial civilization. An artistic retrospective, the "Centennial", was also organized to exhibit the works of the major French painters operating between 1789 and 1889, from David to the Impressionists, including Monet, Pissarro, and Cézanne. The Italian Volpini, owner of the famous Grand Café, obtained a licence to serve beer in the Beaux-Arts building, just beneath the Eiffel Tower. Emile Schuffenecker offered to decorate the walls of Volpini's bar with the works of new artists collectively named "Impressionist and Synthetist Group". Among the paintings exhibited there were 17 works by Gauguin and many by Schuffenecker, Bernard, Laval, Léon Fauché, Louis Roy, Georges-Daniel de Monfreid, and Louis Anquetin. Theo van Gogh did not enter any works by Vincent bacause he considered this show a poor second-best to the official exhibition to which his brother had not been invited. The show went virtually unnoticed by both the public and the critics, although it did impress some young artists, the future Nabis.

■ Drawing of the 1878 Exhibition, Le Trocadero, Musée Carnavalet, Paris. With each exhibition, pavilions became increasingly grandiose in an attempt to impress foreign visitors and flaunt France's technological superiority.

■ Illustration showing various views of the 1867 Exposition Universelle, Civic print collection, Milan. The international exhibitions were a good opportunity to compare, and understand the customs of people living outside Europe.

■ This photograph of the 1889 Exhibition demonstrates how popular these events were. They quickly became an important exercise in international relations.

■ This illustration shows the entrance to the Javanese Kampong at the 1889 Exhibition. Works of art from outside Europe always aroused great curiosity as well as a more serious interest from artists and scholars.

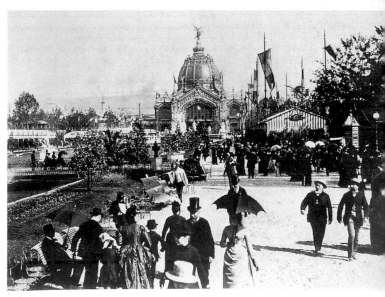

65

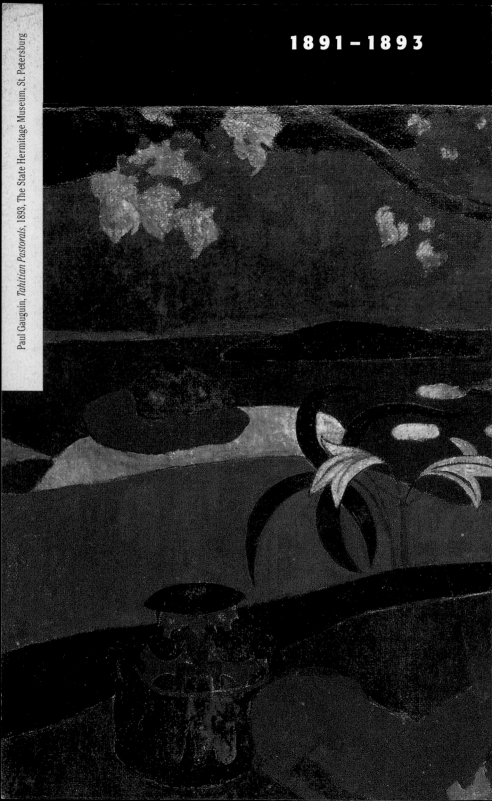

1 8 9 1 – 1 8 9 3

Papeete

On April 4, 1891, Gauguin left for Tahiti, where he arrived on June 9, after more than two months at sea. Upon his arrival in Papeete, the main port on the island, he joined the celebrations for July 14, which continued for several weeks; soon after he attended the funeral of Pomaré V, Tahiti's last king. Following the trend he had started in Brittany, he executed many sketches of landscapes and people that he would later use for his main paintings. Called "documents", these initial rough sketches helped him understand the subtle colors and the effects of light of his new environment. He used to carefully observe and study people, hoping to capture their facial features and physical proportions, as well as their habits and gestures. Gauguin's drawings reveal a consummate skill, since by now he had become fully confident in his expressive means. In order to earn a living, he tried his hand at portraiture but, in spite of his contacts, the local European community was rather unreceptive; only Suzanne Bambridge commissioned a portrait from him, and she insisted on paying less than Gauguin requested. Of English origin, and the wife of a local dignitary, Suzanne Bambridge knew many important people at court. She also spoke fluent Maori, and introduced Gauguin to the island, its people and customs.

■ Before going to Tahiti, in February 1891, Gauguin posed for a photograph for painter Boutet de Monvel. In this carefully studied portrait meant for his family, Gauguin tried to come across as a mature, responsible man making considered decisions about his future.

■ *The Meal*, 1891, Musée d'Orsay, Paris. This painting develops on two separate planes. In the shaded background Gauguin placed the three shy children. In the foreground he painted an exotic still life invested by light and dominated by the deep red of the local bananas, called *fei*.

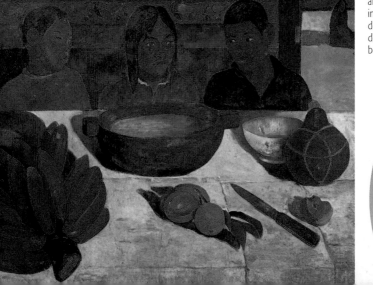

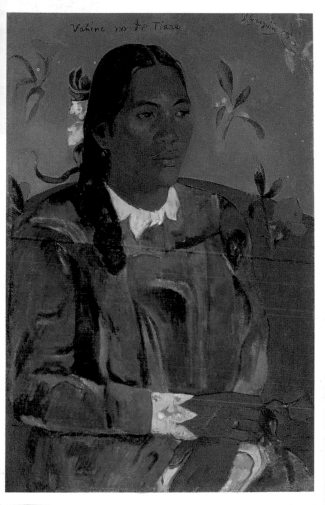

Vahine no te Tiare

■ *Woman with a Flower*, 1891, Ny Carlsberg Glyptothek, Copenhagen. This is one of Gauguin's first Maori portraits. In *Noa Noa* he wrote of his fascination with exotic women, and his difficulties in persuading them to pose for him.

■ *Portrait of Suzanne Bambridge*, 1891, Musées des Beaux-Arts, Brussels. This is a conventional work that comes to life only in the elaborate decoration on the dress.

■ French Polynesia comprises 115 islands, collected in five main archipelagoes.

■ *Young Tahitian Boy with a Tiaré Flower*, 1891, Private Collection, United States. One of the few male portraits executed in Polynesia, this painting appealed to Henri Matisse who purchased it in 1899 from Vollard. It inspired some of his own works.

The Flowers of France

This painting, dated 1891, was the first of many to be given a Tahitian name, *Te Tiare Farani*. The still life with flowers, a typical Impressionist subject, is given a new, exotic reading here. Today it hangs in the Pushkin Museum, Moscow.

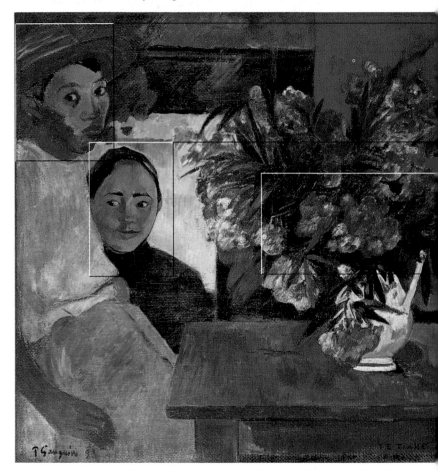

■ Gauguin's Polynesian experience altered his way of interpreting color and light. Whereas in Brittany he had preferred pure, simple colors, in the Pacific he experimented with new shades and hues, positioned in an seemingly random way, that brought out the true radiance of the subject, as testified by these beautiful flowers. In this work the soft light seems to emanate from an indirect source.

■ When he realized that his career as a portrait artist for the local European community was not likely to take off, Gauguin turned to the indigenous population, who had welcomed him with warmth. This melancholy boy looks straight out at the viewers as if to attract their attention. His face is in the shade, while his shirt seems to reflect the flowers' bright colors.

■ Gauguin's female figures, and the attentive, lively young girl in this painting is no exception, are much more expressive than their male counterparts. This picture was preceded by numerous sketches, pastel drawings, and gouaches, that Gauguin used as preparatory studies. He was also influenced by what he used to call his "little museum", a series of artistic reproductions from different periods and cultures that he had brought from Paris.

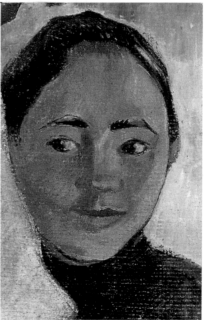

The colonization of the Pacific

■ Robert Bénard, *Cook's Arrival at the Tongas*. The author of this engraving naïvely confused the "myth of the primitive" with the "myth of the ancient", and gave the native people anachronistic costumes, as if Cook had landed in ancient Greece.

After Magellan's journey in 1521, the first European settlers to land on the Pacific islands were the Spanish and the Portuguese, followed by the Dutch, who organized the East India Company soon after 1600. In 1606 Tahiti was discovered, and the Europeans started to exploit its coconut, cotton, coffee, and sugarcane plantations. A more systematic exploration of these lands started only in the early 1800s thanks to seafarers like the French Louis Antoine Bougainville and the English James Cook, who sailed there three times between 1768 and 1779. Soon, missionaries became eager to spread European culture and religion to the indigenous population of the East Indies. When the first artefacts of these new cultures started to arrive in Europe, they were put on display in new, specially-created ethnographic museums: in 1878 the Musée des Missions Ethnographiques was opened in Paris, followed by the Musée d'Ethnographie at the Trocadéro. France and England continued their colonial expansion over the next few decades, until they had control over virtually the whole of the Pacific. They introduced new plants, such as corn and citrus fruit, as well as breeding stock and farmyard animals, which were unknown to indigenous populations.

■ The organizers of the 1889 Exposition Universelle in Paris reconstructed a typical village of Tahiti and New Caledonia at the Champ de Mars. For the first time, the artefacts could be seen and studied in their "real" environment.

■ This photograph shows the Tahitian pavilion at the 1900 Exposition Universelle in Paris. Thanks to an increasing number of exhibitions, the interest in artefacts from the Pacific soon grew. Collectors of these art objects were supported by a few specialized galleries.

■ The cover of this 1901 children's book represents the European countries' rush to establish their own power over the colonies, a process justified as civilization.

■ Funded in 1879 and planned by Hamy, the Musée d'Ethnographie in Paris, represented here in a contemporary print, opened its doors in April 1882.

Racism

The historical reasons for racism in Europe can be found in an book by Joseph-Arthur de Gobineau, *Essay on the Inequality of Human Races* (1853–55). His theories formed the basis of *The Foundations of the 19th Century*, an influential work by Houston Stewart Chamberlain, published in 1899. These ideas were adopted to justify colonial conquests: in 1900, 90.4% of Africa and 98% of Oceania were controlled by European or American settlers.

■ This engraving shows a model wearing the mask of a chief of the Kanaka tribe, of New Caledonia, at the 1878 Exposition Universelle in Paris. The artefacts shown at the 1878 and 1879 Exhibitions were incorporated into the main collection at the Musée d'Ethnographie in Paris.

Mataïea

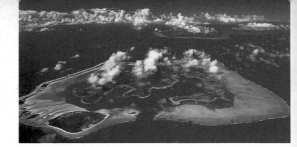

Disappointed by Papeete's European flavor, while still recovering from a severe bout of bronchitis, Gauguin left the city to look for an environment that was still unspoiled and wild. He moved to Pacca and then to Mataïea, on the south of the island, where he rented a *fare*, a bamboo hut with a roof made of palm leaves. He lived in the thick of tropical vegetation, in front of a blue lagoon, with a girl of mixed blood who had accompanied him there, Titi. When she returned to Papeete, she was replaced by Teha'amana. Eager to discover more about the Maori and their rituals, Gauguin read Moerenhout's *Voyages aux Iles du Grand Océan*. The influence of this book is clear in his paintings as well as his writings, *Ancient Maori Cult* and *Noa Noa*. He painted continuously, but was depressed by the poor sales of the pictures he had sent to Paris. Only de Monfreid used to regularly send him money.

■ The lands above sea-level that constitute the five archipelagoes of French Polynesia are of two types: volcanic peaks and flat islands, called *motu*, that combine into low-lying coral atolls.

■ *Ia orana Maria (We Greet thee, Mary)*, 1891–92, The Metropolitan Museum of Art, New York. Unlike the rest of the population, the people of Mataïea were mostly Catholics. This inspired Gauguin to paint Jesus and Mary in Tahitian fashion.

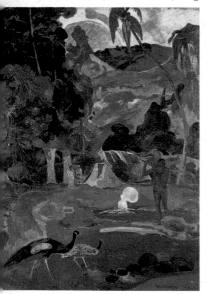

■ *Death*, 1892, Pushkin Museum, Moscow. In this painting Gauguin included the hut he had rented: it faced the sea on one side, and the mountains on the other.

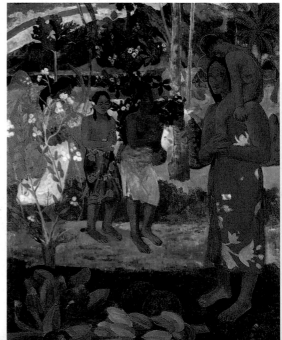

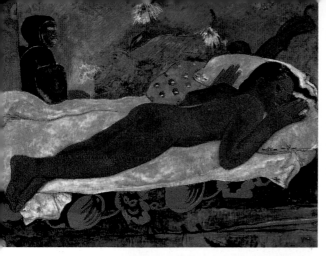

■ *Manao tupapau (The Spirit of the Dead Watching)*, 1892, Albright-Knox Art Gallery, Buffalo. This complex and heavily symbolic work was inspired by a ghostly vision Teha'amana had had, and by her irrational, fearful belief that darkness was populated by phantasms.

■ *Arearea (Joyfulness)*, 1892, Musée d'Orsay, Paris. This painting is part of an unofficial triptych that also includes *Once upon a Time* and *Tahitian Pastorals*. In the background some *tamuré* perform in front of an idol of Hina, goddess of the moon. The orange dog in the foreground puzzled French critics, who had the chance to view this painting in Durand-Ruel's gallery in 1893.

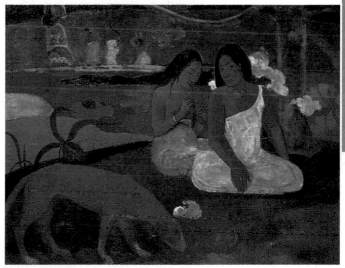

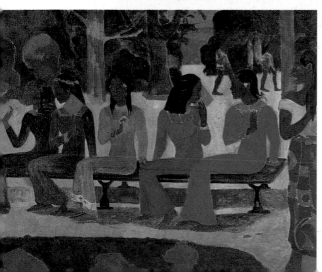

■ *Ta matete (Marketplace)*, 1892, Kunstmuseum, Basel. The position of the women in this painting was inspired by a photograph Gauguin had of an Egyptian fresco in a Theban tomb of the 18th dynasty. This fresco is currently housed in the British Museum in London. The setting also resembles an Egyptian frieze kept in the Louvre.

What! Are you Jealous?

Aha oe feii was a carefully designed picture. This is proven by the many preparatory sketches, especially those for the stretched-out figure, which was added later. Painted in 1892, it is kept in the Pushkin Museum in Moscow.

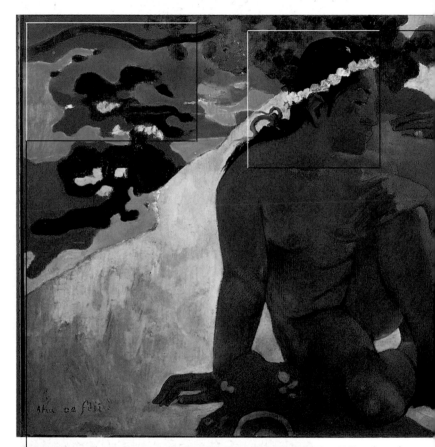

■ Gauguin used colors rather than images to express the symbolic meaning of this work. This remarkable innovation greatly influenced later painting, and was a determining factor in the birth of Abstraction.

■ The pose of the broad, statuesque girl in the foreground is carefully studied. Her strong, decisive personality is revealed in the curve of the nose and the closed lips and, although her face is in profile, her right eye looks out towards the viewer in a mischievous, yet childlike way. Her black hair is in direct contrast with the crown of white flowers on her head, and her dark skin is highlighted by the bright pink sand on the beach.

■ The rapport between the two girls lazily lying on a sunny beach is evoked by their calm, relaxed attitude. The position of the girl in the background is unusual and indicative of Gauguin's desire to look for new artistic solutions.

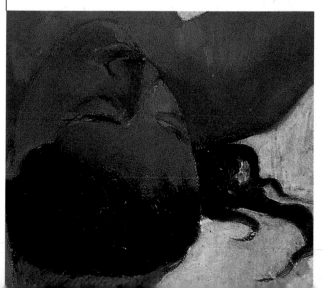

Art in Oceania: nature and magic

■ Kawe Goddess, Nukuoro, Caroline Islands, Auckland Institute and Museum. This is one of the few remaining statues of idols: the majority were destroyed during the missionaries' process of Christianization.

Over the centuries, Oceania was inhabited by many different populations that expressed their culture in highly individualistic art forms. Three main areas deserve particular attention. Australia's aboriginal populations lived by a complex set of religious beliefs, represented in sculptures and engraved or painted decorations. These artefacts carried a distinct symbolic significance according to the tribe that created them and were often only understood by those initiated to a particular cult. In Melanesia, a group of islands northeast of Australia, indigenous populations portrayed their ancestors or spirits in the shape of humans or animals. Their artistic techniques were extremely advanced, especially in terms of carving, engraving, weaving, and decorating with bird feathers. In New Guinea, Melanesia's main center, nine different stylistic currents developed, in particular around the rivers Sepik and Massim, where the locals built ceremonial canoes with heavily decorated bows. Finally, in Polynesia and Micronesia the many social groups were portrayed by a variety of badges of honor, such as maces, sceptres, cloaks and headgear, amulets, and breast-straps, all decorated with human figures or geometric motifs.

■ Figure, Papua New Guinea, Brignoni Collection, Bern. These sculptures were often kept in large ceremonial houses, also called houses of men, which were the center of social and religious life for the populations of New Guinea.

■ Sulka shield, Musée Barbier-Mueller, Geneva. Painted on wood with bright colors and decorated with feathers and fibres, this shield is one of the best artistic expressions of the populations in the New Britain Islands

■ *Idol with a Pearl*, c.1892, Musée d'Orsay, Paris. Gauguin had a good knowledge of Oriental religions: here he created a fusion of two different cultures by giving the idol typically Polynesian features, and a Buddha-like position. The pearl on the forehead represents the third eye, or inner vision.

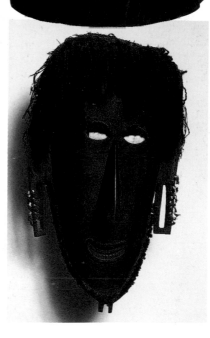

■ Ceremonial mask, Witu Islands, New Britain, Musée Barbier-Mueller, Geneva. Every single decorative element in this mask had a precise meaning and function.

■ Totemic mask, Saibai Islands, Papua New Guinea, Friede Collection, New York. Usually these masks represented the ancestors' spirits or supernatural beings.

Once upon a Time

Matamua, the title of this 1892 painting is a nostalgic reference to when the island was unspoilt, that is before the arrival of European settlers. It is part of the Thyssen-Bornemisza Collection in Madrid.

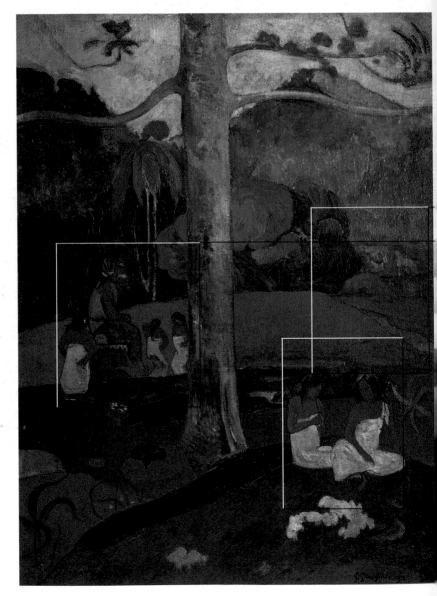

■ Near the large mango tree "masking the entrance to the grandiose cave at the foot of the mountain" is Gauguin's hut, already portrayed in *Death* (p. 74) and other works. In order to represent those places, it was necessary for the artist to immerse himself in the environment, to live and feel it completely, rather than just be a spectator.

■ In Tahiti Gauguin searched for sculptures of ancient gods, but the only evidence of their existence were oral tales and Moerenhout's book. In the background is a statue of Hina, goddess of the moon (see also *Arearea*, p. 75). Fatou, the god that had created the Earth, was born from Hina's union with Taaroa, supreme god and creator. Their cult was tied to the themes of death and resurrection.

■ The atmosphere of holiness and the imaginary re-enactment of ancient rituals is underlined by the presence of the woman playing the flute, called *vivo* in the Maori language. In his book *Noa Noa* Gauguin wrote about falling asleep on many a quiet night, accompanied by the soothing sound of this instrument, which he associated with his sweetest dreams. The same two women also appear in *Arearea* (p. 75).

The first Nabis exhibitions

W hile Gauguin was in Tahiti, in France his art had become the inspiration for a group of artists that belonged to the second generation of Symbolists, the Nabis. The group formed after Paul Sérusier showed his friends at the Académie Julian a small landscape of Pont-Aven that he had painted on Gauguin's advice. Most of these students, born between 1860 and 1870, had met at the Lyceé Condorcet or at the École des Beaux-Arts: they formed a close-knit group whose interests included painting, literature, decorative arts, and the theatre. One of them, Auguste Cazalis, put forward the name Nabis, from the Hebrew *Nabiim*, meaning prophet; Maurice Denis suggested that the name alone made them feel "like initiates, as if we were part of a mystical, secret society". The Nabis used to meet in Ranson's studio or at the headquarters of the *Revue Blanche*. From 1891, they exhibited at the Salon des Indépendants, where they caused a sensation, at the Salon de l'art nouveau, of which they are considered the forerunners, and many other shows. They began to disband in about 1900.

■ Paul Ranson, *Nabis Landscape*, 1890, Josefowitz Collection, Lausanne. Cazalis gave nicknames to his Nabis friends: Ranson, for example, was known as "the Japanese Nabi".

■ Paul Sérusier, *Melancholy*, c.1890, Boutaric Collection, Paris. Sérusier was nicknamed "the Nabi with the glowing beard". During their meetings, the Nabis used esoteric jargon.

■ Aristide Maillol, *Woman with a Scarf*, 1919–20, Private Collection. Matisse was an admirer of these classic sculptures.

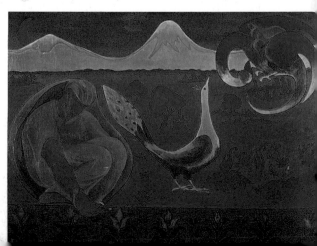

■ Pierre Bonnard, *Young Girl with a Cat*, 1906, Private Collection. Bonnard's personal exhibition of 1896 was harshly criticized by Pissarro and marked the end of his contact with the Impressionists.

■ Félix Vallotton, *Woman Writing*, 1904, Private Collection. Called the "foreign Nabi" because of his Swiss origins, Vallotton joined the group in 1892 and became well-known thanks to the shows organized by Vollard in 1897 and 1898.

■ Edouard Vuillard, *The Bernheim Brothers*, 1912, Private Collection. Vuillard's beard earned him the nickname "Zouave Nabi". Maurice Denis was the "Nabi of beautiful images".

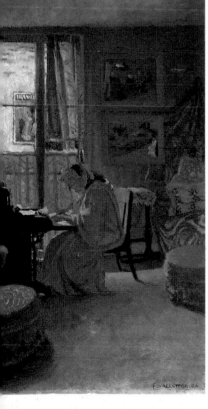

Teha'amana

Soon after his arrival in Mataïea, Gauguin set off to explore Tahiti's wild coast. During the journey, a native of the Fa'aone district invited Gauguin into his hut, where he was offered breadfruit, wild bananas, and prawns. When asked where he was going, the artist candidly admitted being on his way to the near district of Hitia'a "to find a woman". The native's wife, thinking that he was just another rich, extravagant European man looking for a taste of the exotic, replied: "If you need a woman, I have one for you right here: my daughter". This was how Gauguin, at the time 43 years old, met Teha'amana, a 13-year-old girl who was to become an important source of inspiration for his art. Enchanted by her beauty, Gauguin asked her to be his wife according to the Tahitian formula Suzanne Bambridge had taught him. As he narrates in *Noa Noa*: "I greeted her. She smiled and came to sit next to me. 'Are you not afraid of me?', I asked her. 'No.' 'Would you like to spend the rest of your life in my hut?' 'Yes.' 'Have you ever been ill?' 'No.' That was all".

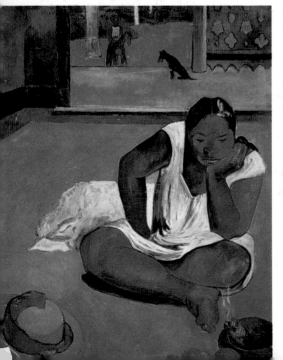

■ *Silence*, 1891, Art Museum, Worcester. Teha'amana, also called Tehura, was Gauguin's *vahiné*, his mistress. Her exceptional expressive ability enabled her to model for many of his most beautiful paintings.

■ *Teha'amana has many Ancestors*, 1893, The Art Institute of Chicago. Teha'amana was the primitive Eve of Gauguin's dreams, and her comforting presence turned the months they spent together into one of the happiest periods in his life, as well as one of the most prolific.

■ *Faaturuma (Rêverie)*, 1891, Nelson-Atkins Museum of Art, Kansas City. Teha'amana's rapt face and posture perfectly convey the image of a melancholy and dreamy woman. The dark color of her skin is brought to life by the intense red of her dress, which is in turn highlighted by the blue wall in the background.

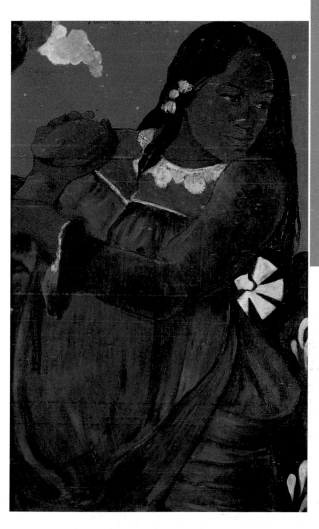

■ *Vahine no te vi (Woman with a Mango)*, 1892, Museum of Art, Baltimore. Traditionally, in Tahiti mangoes are the symbol of fertility: here the presence of the fruit is clearly a reference to Teha'amana's imminent motherhood.

1891–1893

Where are you Going?

Ea haere ia oe?, the title of this 1893 painting suggests an unspoken dialogue between the girls and highlights the routine of daily situations, which Gauguin saw as the basis for a happy life. It is now in the Hermitage Museum, St. Petersburg.

■ Gauguin used to recycle characters and settings, introducing minor changes in proportions or in lighting. This was done in an attempt to improve on the original work, but, at times, merely to create a game of allusions. The woman squatting on the grass is identical to the figure in the foreground of another painting, *When will you Marry?* (inspired by Delacroix's *Women of Algiers*): the only differences are in the *pareo* (blue, instead of red) and in the absence of the flower in her hair.

■ In 1895 Strindberg commented on these paintings, saying that he could not understand and appreciate them: "You created a new land and a new sky, but I cannot picture myself within your creation: it is too bright for a lover of *chiaroscuro* like myself. And your paradise is inhabited by an Eve who is not my ideal".

■ In this version of the same painting, (*Where are you Going?*, 1892, Staatsgalerie, Stockholm) the background is unchanged except for the absence of the woman with the child. The figure in the foreground, however, is very different: she is holding a puppy and will be an inspiration for the sculpture *Oviri* (see p. 104).

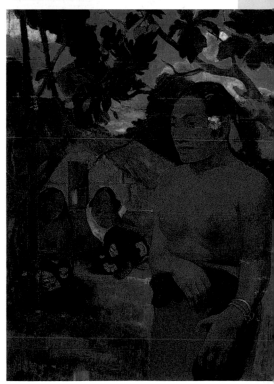

1891–1893

The Pacific after Gauguin

■ Emil Nolde, *Native Woman and Child*, New Guinea, 1913–14, Private Collection. The sketches and paintings of this period reflect the fresh and poetic intensity of the places that inspired them. Gauguin had an enormous influence on the Expressionists.

Gauguin's experience in Polynesia aroused perplexity at first, even irony. When his paintings became more familiar, however, many artists tried to follow his exotic itinerary, hoping to capture the same magic in their own works. For example, Emil Nolde took part in Külz-Leber's 1913 anthropological expedition to the Pacific islands, where Germany had a protectorate, to study and document indigenous life in a series of sketches and paintings. From this experience he gained greater sensitivity in the use of color, a heightened sense of decoration, and a more decisive expressive vigor. In April 1914, Hermann Max Pechstein and his wife went to the Palau Islands, near New Guinea. Although his approach to the artistic expressions and lifestyle of the natives was very different from Gauguin's, he created a series of paintings characterized by an extraordinarily lively chromatism and definite narrative strength. The Pechsteins' stay was brusquely interrupted by the start of World War I and the Japanese invasion of the islands. Finally, from February 27 to July 31, 1930, Henri Matisse travelled around Tahiti and Tuamotu. He returned to France with a large quantity of drawings and impressions.

■ Hermann Max Pechstein, *Ankunft in Palau*, 1917, Private Collection. This work is part of a famous series Pechstein executed upon his return from the Palau Islands.

■ Emil Nolde, *Bust of a Native*, New Guinea, 1913–14, Private Collection. The outline is clear and well-defined, while the severe expression on the face is captured with immediacy and spontaneity.

■ Henri Matisse, *Polynesia, the Sea*, 1946, Musée National d'Art Moderne, Paris. In the last years of his life, Matisse experimented with the technique of *papiers découpés*; he represented the lively, intense colors of Tahiti in two large panels, one dedicated to the sky, the other to the sea. In a letter to his son he wrote: "I put my head underwater, and I witnessed marvellous sights, corals of all colors and shapes, inhabited by amazing types of fish".

■ Henri Matisse, *Window in Tahiti*, 1935–36, Musée Matisse, Nice. One of Matisse's favorite subjects, the open window facing the sea is interpreted here with a new intense light. The outlines are loose and free, and the decorative aspect of the composition is given a strong relevance. The whole is inserted within a fairytale-like setting.

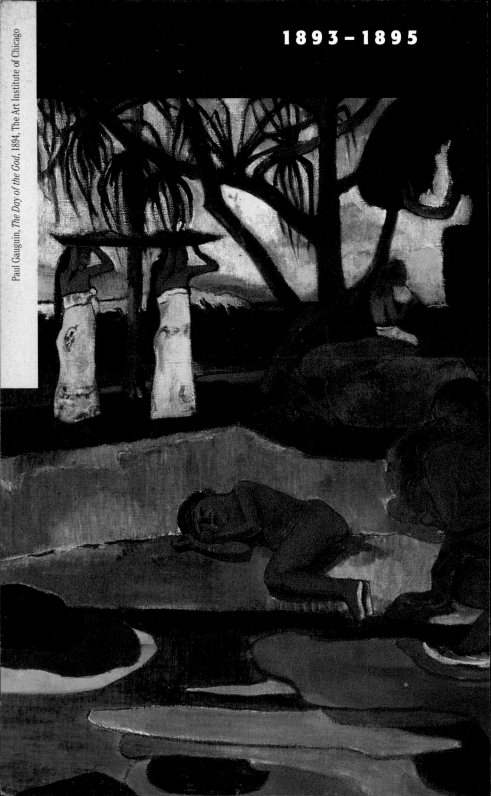

1893–1895

Paul Gauguin, *The Day of the God*, 1894, The Art Institute of Chicago

Return to Paris

1893: the first great exhibition

In April 1893 Gauguin left Tahiti and, three months later, landed in Marseilles. Although poorer and more ill than he had ever been, he managed to rent a small studio in rue de la Grande Chaumière with the money de Monfreid had sent him. When Isidore, his uncle in Orléans, died, Gauguin also received an inheritance of 9,000 francs that enabled him to pay off his debts and rent a larger studio in rue Vercingétorix. In the meantime the rapport with his estranged wife had become even more troubled: he resented her selling some paintings from his own collection without his permission, while she disapproved of the way he was using his inheritance money. The grudges they bore towards each other were stronger than their desire to bring the family together, and neither was prepared to make the first step. Following the recommendations of Degas, who was a keen admirer of Gauguin's art, the Durand-Ruel gallery organized his first great personal exhibition from November 4 until December 1, 1893. He put 44 paintings on show, six Breton pictures and 38 Tahitian ones, as well as two sculptures: his works aroused a great deal of interest and caused a sensation. However, in spite of the enthusiasm of the young Nabis and Mallarmé's opinion, according to which "it is incredible that someone could put so much mystery into so much splendor", most of the critics and public failed to understand his art and remained unmoved by it.

■ Gauguin used this photograph of himself wearing an astrakan hat for his *Self-Portrait with Palette*, which he dedicated to Charles Morice. The show at Durand-Ruel's gallery did not go as well as expected: only 11 works were sold, six of which were Breton paintings.

■ *Noa-Noa* means "richly fragrant". This is the adjective traditionally given to Tahiti, and the title of Gauguin's book, written in 1893, in which he tells about his life in Polynesia as well as airing his artistic views. The text was accompanied by many of his own engravings and several poems by Charles Morice.

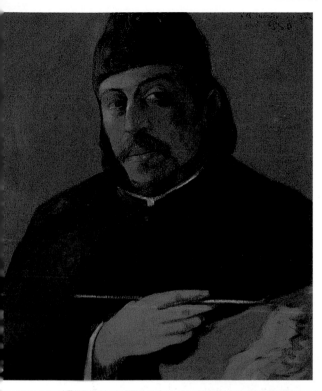

■ *Self-Portrait with Palette*, 1893–95, Private Collection. Gauguin was eager to maintain the original titles of his works in the Maori language to further explain and illustrate the local culture. However, the small-minded public viewed this decision with scorn, while the critics thought it unnecessary and tiresome.

■ *Nave Nave Moe (Delicious Water)*, 1894, The State Hermitage Museum, St. Petersburg. Gauguin brought many notes and sketches to France that enabled him to continue to create Tahitian paintings. The elements of this work are typical: a mango, Tahitian women, and a ritual dance for the goddess Hina.

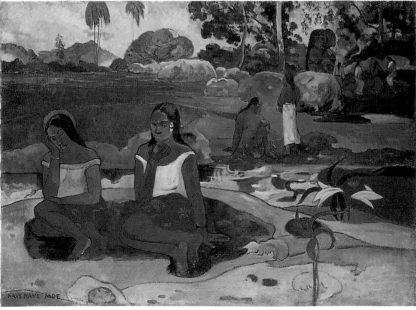

Self-Portrait with a Hat

This self-portrait, executed in 1893, is set in the studio of rue Vercingétorix, which Gauguin had painted with bright yellows and greens, and decorated with Tahitian objects and fabrics. The painting now hangs in the Musée d'Orsay, Paris.

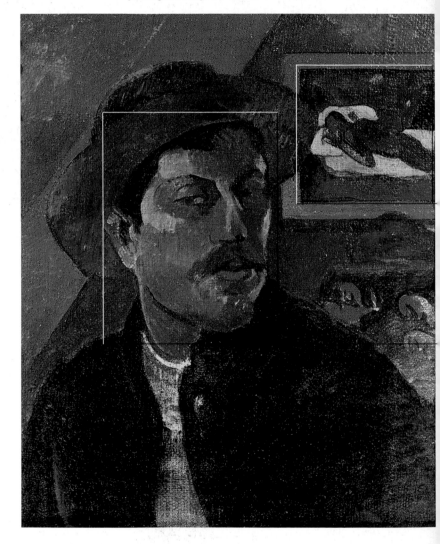

■ This photo, taken sometime in 1893 or 1894, shows Gauguin in his studio. He sits in front of *Silence*, a work he was fond of because of its stylistic solutions, but also because it succinctly conveyed the idea of melancholy.

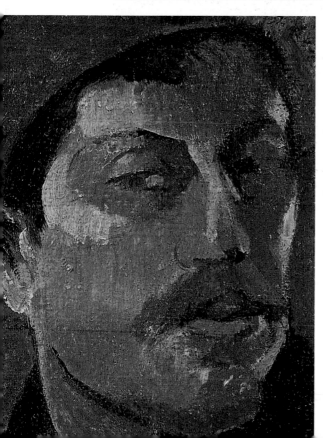

■ In the background Gauguin placed what he considered his best Tahitian painting, *Manao tupapau*. This work, however, appears back to front, because, in typical fashion, Gauguin used a mirror to create his self-portrait.

■ An uncommon art form in the past, self-portraits became popular toward the end of the 19th century among artists such as David, Ingres, and Delacroix. It became the pictorial equivalent of diaries and autobiographies, which were also growing increasingly common. Gauguin painted self-portraits on a regular basis: for him it was a way of looking into himself in search of his spiritual identity.

BACKGROUND

France at the end of the 1800s

■ Marevna Vorobieff Rosanovitch, *Homage to my Montparnasse Friends*, 1918, Musée du Petit Palais, Geneva. Montparnasse was the heart of Paris, the mine of new artistic ideas.

■ Henri de Toulouse-Lautrec, *Jane Avril Dancing*, 1892, Musée d'Orsay, Paris. Most of Toulouse-Lautrec's work was devoted to Parisian nightlife. He portrayed both its bright artifice and its misery.

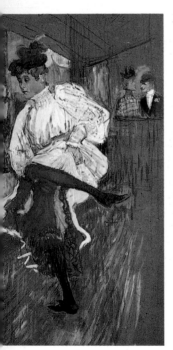

During the last decade of the 19th century, the government of the Third Republic in France was mostly in the hands of the Moderates. Anti-clerical feelings that had grown in previous years began to die down following Pope Leo XIII's encyclical in 1892, which invited all Catholics to take an active part in the life of the State. Workers' associations and socialist movements, although split into numerous groups, continued to grow and began to represent a real political force: in 1893, fifty of their delegates were elected to Parliament. French foreign policy continued to focus on colonial expansion in Indochina and Madagascar. In Africa, however, the French had to bow to England's superior strength, as exemplified by the incident in El Fasher, Sudan in 1899. The Moderate government was undermined in 1893 by the Panama Scandal, which revealed a high level of internal corruption, and by the Dreyfus affair. Dreyfus was a Jewish official sentenced to life imprisonment for espionage in 1894 and subsequently redeemed after a strenuous defense campaign carried out by the press and many intellectuals, including Zola. In 1899, the Radicals, Republicans, and Socialists united in the so-called Left-wing bloc, and created the governmental ministry of Waldeck-Rousseau and Emilio Combes. In spite of prosperous economic conditions, the country went through a difficult period during which tensions with the Catholics increased again, as did union demands.

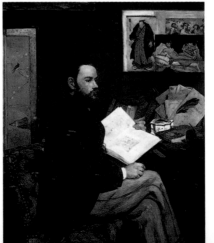

■ A contemporary image of a Parisian clochard, a figure "celebrated" by poets and chansonniers alike. Gauguin himself had realized that the French capital offered many opportunities for people who were well-off, but was "a real desert for the poor", a cruel and heartless city.

■ Emile Zola, here portrayed by Edouard Manet in 1868 (Musée d'Orsay, Paris), was the forerunner of naturalistic novels, in particular thanks to his series *Rougon Macquart*.

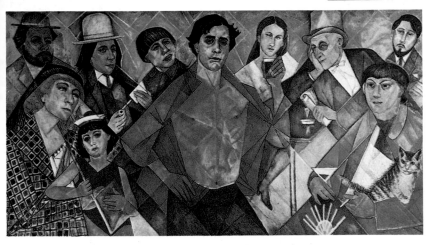

■ The first shooting and projection device for a cinema was developed by the Lumière brothers, Louis Jean and Auguste, in 1895. The dream of an art form able to represent reality as it was happening had finally come true.

The Clochards

The bright lights, sumptuous salons, and theaters could not hide another side of Parisian life, the clochards. According to Article 270 of the French penal Code, clochards were tramps, people with no occupation, no fixed abode, and no means of substinence, that is those who walked *à cloche-pied*. At the end of the century the slums of the Ville Lumière were populated by a multitude of poor people and outcasts, who had come from all parts of France and from neighboring countries in search of a better life in the capital. Their roaming, dire existence has been described by painters and illustrators, such as Toulouse-Lautrec and Bernard, by writers, such as Balzac, Hugo, and Zola, and by chansonniers, like the famous Bruant.

1894: the studio in Montparnasse

Upon his return to Paris, Gauguin decided to astonish those around him by developing an eccentric and casual persona in the naïve hope that, by attracting attention upon himself, his paintings would become better known. However, his behaviour had the opposite effect, and drove away even those few collectors who had until then shown an interest in his art. In December 1893, gallery owner Vollard introduced him to Annah, a 13-year-old Javanese half-caste girl who became his lover. The artist had transformed his studio into an exotic place, a small corner of the South Seas decorated with photographs, trophies, weapons, wooden sculptures, fabrics, and other Polynesian artefacts. At the entrance he had placed a controversial inscription, *Te faruru* (Here we love), and a series of explicitly erotic paintings. Annah's ambiguous and impudent presence, along with the obscure Maori terms Guaguin used, became the source of vicious gossip, so much that the weekly meetings with his regular guests, painters and intellectuals, were seen by the comformists as unseemly orgies.

■ This photograph shows some of the guests who enlivened the evenings that Gauguin hosted in his studio: in the centre is cellist Fritz Schneklud, next to him musician Larrivel, and in the background Sérusier, Annah, and sculptor George Lacombe.

■ *Breton Girls*, 1894, Musée d'Orsay, Paris. By the time Gauguin returned to Pont-Aven and to traditional Breton subjects, his artistic style had completely changed.

■ Annah, shown here in a photograph by Alphonse Mucha, had arrived in Paris as a maid to singer Nina Pack, who had named her Anna Martin.

■ *Upaupa Schneklud (The Cello Player)*, 1894, Museum of Art, Baltimore. For this portrait of the Swedish musician Fritz Schneklud, Gauguin sought inspiration in the *Self-portrait with a Cello* by Courbet, which was part of Arosa's collection and of which he had a photograph.

■ *Arearea no varua ino (The Amusement of the Evil Spirits)*, 1894, Ny Carlsberg Glyptothek, Copenhagen. This painting is yet another variation of Tahitian themes. The dedication to Madame Gloanec, however, indicates that it was executed during his stay in Brittany.

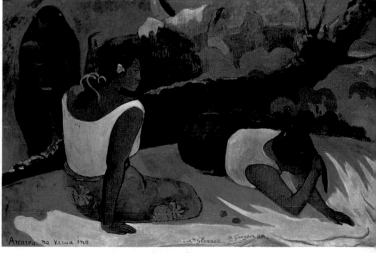

Annah the Javanese

The full title of this work is typically Symbolist: *Aita tamari vahine Judith te parari* (*The child-woman Judith is not yet breached*), a reference to his friend Molard's step-daughter. Painted in 1893–94, it is now in a private collection.

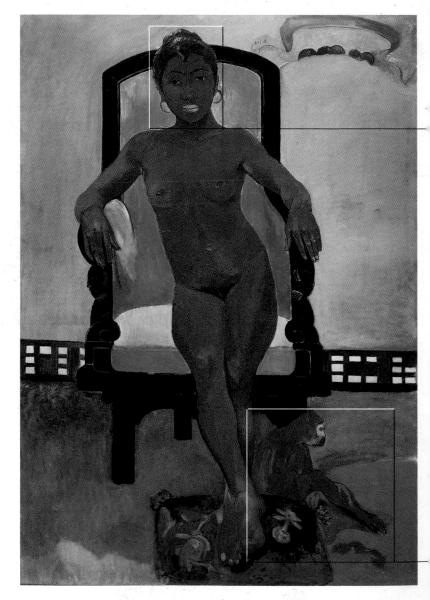

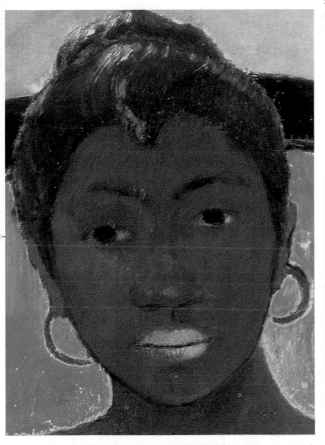

■ The girl's face is drawn with a few delicate lines. As in many other Tahitian paintings, the model does not look straight at the viewer, but slightly to one side, in a pose that makes her even more enigmatic and mysterious.

■ Guido Cagnacci, *Cleopatra*, Private Collection, Milan. Gauguin's nudes can be reminiscent of the melancholic sensuality of 17th-century art. The inner drama, however, is never theatrically represented.

■ In order to shock Parisian audiences, Gauguin used to walk around with Annah while she flaunted their pet monkey Taoa on a lead, or held a colorful parrot on her arm.

Vuillard and Vallotton

Edouard Vuillard joined the Nabis in 1890 and became one of their main representatives. From early in his career, he portrayed friends and relatives in their quiet, domestic intimacy. An example of this is *Marie penchée sur son ouvrage* (Private Collection), painted in about 1891, in which he portrayed his sister Marie, who was later to marry another member of the Nabis group, Ker Xavier Roussel. He painted both interiors and large decorative panels, and his style was characterized by delicate colors and refined design. Félix Vallotton left his hometown of Lausanne in 1882 to enrol at the Académie Julian. He worked as a copyist at the Louvre for a few years, an experience that allowed him to perfect his sketching ability. Although a Nabis, he did not share their passion for Symbolism, and developed a new, noncomformist use of colors. Throughout his life he focused on subjects that revealed his decorative talents.

■ Félix Vallotton, *Still Life with Flowers*, 1913, Private Collection. Vallotton's still lifes with flowers are faithful representations of the Nabis theories. Gauguin's lesson is also evident in the emphasis on pattern and in the innovative use of brightly intense colors.

■ Félix Vallotton, *Still Life with Flowers and a Lemon*, 1924, Private Collection. An admirer of Cézanne, Vallotton's work inspired many of Matisse's still lifes.

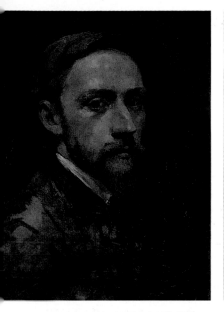

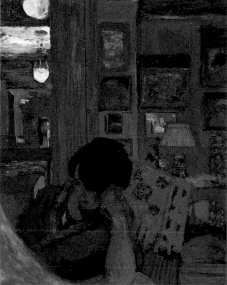

■ Edouard Vuillard,
Portrait of Lucy Hessel,
c.1915, Private Collection.
In 1900, thanks to
gallery directors
Bernheim-Jeune,
Vuillard met Jos Hessel,
a famous art dealer.
He established a strong
friendship with Hessel's
wife, Lucy, who became
his confidante and
the inspiration behind
many of his paintings.

■ Edouard Vuillard,
*Young Woman at the
Piano*, 1934, Private
Collection. In this
portrait, Vuillard barely
sketched the other
objects in the room:
to him they were just
a means to underline
the personality of the
person portrayed.
This painting is an
example of his acute
psychological awareness.

1894–95: farewell to Europe

In the spring of 1894, after a short trip to Brussels, Gauguin and Annah returned to Brittany. After selling her inn at Le Pouldu, Marie Henry had kept the artist's paintings as payment of his debts, and he never recovered them. Marie Gloanec had also closed her boarding house to open a smaller one, L'Ajoncs d'or, where Gauguin lived for some time. He tried to re-establish his leading position within the artistic community in Pont-Aven, but most painters had already chosen a direction and had no interest in his lessons. To make things worse, local people were not tolerant of his eccentric young lover, and the tension between the two parties even led to a brawl in which Gauguin broke his ankle. Under the pretence of preparing the studio for his return to Paris, Annah abandoned him, taking every valuable object in the house. Disappointed, embittered, and in poor health, on February 18, 1895 he gathered all his paintings and put them up for sale in an auction at the Hotel Drouot. It was another failure: he only sold ten paintings out of the 49 he exhibited.

■ *Portrait of Stéphane Mallarmé*, 1891, Bibliothèque Nationale, Paris. Gauguin was an admirer of Mallarmé, and he dedicated this work, his only etching, to him.

■ *Oviri (Savage)*, 1894, Musée d'Orsay, Paris. The inspiration for this figure, a recurring presence in Gauguin's work, can be traced to Balzac's *Seraphita*. She is also known as *"La Tueuse"* (*The Murderess*).

■ *Young Christian Girl*, 1894, Sterling and Francine Clark Art Institute, Williamstown: The identity of the praying Breton girl is uncertain: she could be de Monfreid's lover.

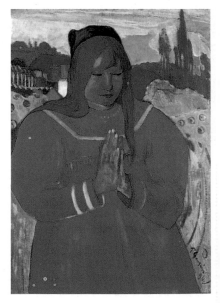

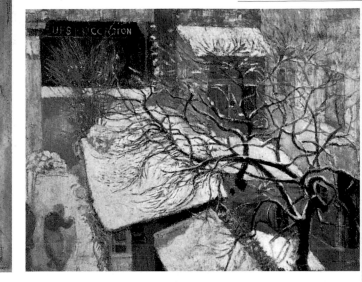

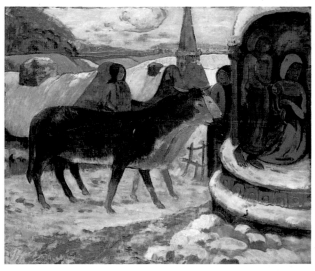

■ *Paris in the Snow*, 1894, Van Gogh Museum, Amsterdam. Painted after his sojourn in Belgium, this work has clear Impressionist influences. It shows the roofs of Montparnasse viewed from his studio.

■ *Christmas Eve*, c.1894, Josefowitz Collection, Lausanne. Gauguin painted this picture in Brittany and brought it to Tahiti along with *Village in the Snow*, painted at about the same time.

Strindberg's refusal

On the eve of the exhibition organized by Drouot, Gauguin asked Auguste Strindberg, who had been a regular presence at his studio, to write the preface for his catalogue. The Swedish playwright refused, admitting that, although fascinated by Gauguin's art, he could not "understand or love it". Gauguin published the letter Strindberg had sent along with his own reply. In his letter Gauguin acknowledged "the enormous chasm between your civilization and my primitive state: the former weighs you down, while my uncivilized state to me is life itself".

The David Mill at Pont-Aven

In Pont-Aven, Gauguin returned to creating classic Breton landscapes such as this 1894 work, which is now in the Musée d'Orsay. The colors are similar to those used in Arles with van Gogh, although the influence of Polynesia is evident.

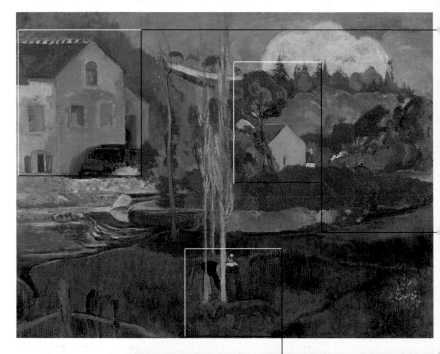

■ The dog in the foreground is similar to the one in *Arearea* (pp. 74–75) and the two women in this scene are much closer in character to his representations of Tahitian women than to those in his early Breton paintings. The artist complained that Breton people had changed: he was not aware that he himself had undergone profound changes as a result of his time in Polynesia.

■ Although during his final stay in Brittany Gauguin painted only a few pictures, they were all remarkable. As confirmed by Maurice Denis, Gauguin's main artistic theory focused on a new, more liberated use of colors. Gauguin told Sérusier: "How do you see that tree? Is it not yellow? Well then put down some yellow, the most intense yellow on your palette; and that shadow is blue, isn't it? Then paint it as blue as you can".

■ Although over the years Gauguin had developed his own distinctive style, the artist had remained grateful to Pissarro for his teachings; indeed both painters still had a shared sensitivity toward nature. In Gauguin's mind, the green fields of Brittany and the vegetation of Tahiti became one: here he portrayed a new landscape where the magic of light and colors recreates an atmosphere similar to that of an earthly paradise, pure and unspoilt.

Denis, Bonnard, and Maillol

Maurice Denis was the main Nabis theorist, and the man responsible for steering the movement towards Symbolism, especially after funding the *Ateliers d'art Sacré* with George Desvallières, where he indulged his desire to focus on religious art. A painter and engraver gifted with great technical skills, he was also fond of applied arts: he sketched and designed stained-glass windows, vases, tapestry, decorative panels, fans, and even a 500 franc note. Pierre Bonnard joined the Nabis after completing his studies in law. He became famous through his graphic works, lithographs, posters, covers, especially those for the *Revue Blanche*, and book illustrations. His paintings often portray landscapes and domestic themes: influenced by the delicate style of Japanese prints, his works are so graceful and harmonious that he is considered one of the major forerunners of art nouveau. Fascinated by Rodin's works, Aristide Maillol studied painting and sculpture at the École des Beaux-Arts. In 1893 he opened a studio in Banylus: although he specialized in tapestry, influenced by the paintings of Gauguin and the Nabis, at the start of the 1900s he switched to sculpture. He was interested in Egyptian and Indian art, in the classic sculptures he had seen in his travels in Italy and Greece, and was influenced by Matisse.

■ Aristide Maillol, *Study for a Monument to Paul Cézanne*, 1914, Private Collection. In 1910 Maillol designed a monument for author Émile Zola which was never completed. He subsequently worked for 12 years on a memorial commissioned for Cézanne.

■ Pierre Bonnard, *Farm in Dauphiné*, 1918, Private Collection. From 1892 until his wedding in 1925, Bonnard spent a great part of the year in his family residence in Grand-Lemps, in the Dauphiné region.

■ Pierre Bonnard, *Woman Washing*, 1924, Private Collection. This sketch belongs to a series of nude studies executed between 1923 and 1925 for Frappier's lithographs.

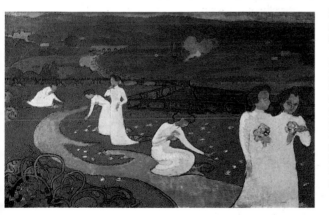

■ Maurice Denis, *Portrait of Yvonne Lerolle in Three Poses*, 1897, Olivier Rouart Collection, Toulouse. In this triple portrait that is as light and delicately graceful as an apparition, the influence of Pre-Raphaelite art, in particular the style of Dante Gabriel Rossetti, is clearly discernable.

■ Maurice Denis, *April*, 1892, Kröller-Müller Museum, Otterlo, Netherlands. This painting forms part of an allegorical triptych of the seasons, which Denis meant to signify the ages of man.

■ Aristide Maillol, *Profile of a Young Woman*, 1894–96, Musée Hyacinthe Rigaud, Perpignan, France. This small Symbolist scene is created with light, delicate touches that resemble the formal sensitivity of Emile Gallé's creations.

Paul Gauguin, *Nevermore*, 1897, Courtauld Institute Galleries, London

1895–97: Tahiti

O n June 28, 1895, Gauguin left Paris, and, on July 3, he embarked for the Pacific Ocean from Marseilles. He had entrusted some of his paintings to Auguste Bauchy and Georges Chaudet, and his writings to Charles Morice. He later left some other works to Daniel de Monfreid and Ambroise Vollard: their regular flow of letters and telegrams became his only connection to France. The journey lasted two months, and included two stops, one in Port Said, and the other in Auckland, in New Zealand, where he visited the Maori art collection at the Ethnology Museum. Gauguin landed in Tahiti in September: he was 47 years old, with little money, and suffering from poor health. Not only was he still afflicted by the consequences of his ankle fracture, he was also contending with heart problems, skin rashes, and alcohol abuse. To make things worse, he contracted syphilis from a prostitute, and his condition became so severe that he was accused of being a leper. In spite of the many hospital spells, the last eight years of his life were a time of intense creativity.

■ Gauguin built himself a bamboo hut with a straw roof in Punaauia, on the west coast of the island, and decorated it with his sculptures. At first he took in Teha'amana, but she left to get married soon after. He found a new *vahinè*, a lover and model in 14-year-old Pahura, who gave him a daughter. Unfortunately the child died a short time later.

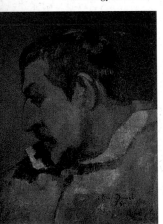

■ *Self-Portrait*, 1897, Musée d'Orsay, Paris. In the winter of 1897 his beloved daughter Aline, to whom he had dedicated the book *Cahier pour Aline*, died of pneumonia. She was 20 years old. Gauguin had a severe depressive crisis, and in February 1898 he tried to take his own life by swallowing some arsenic.

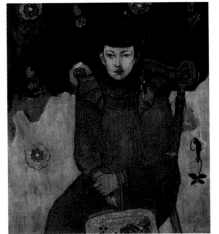

■ *Portrait of Vaïte (Jeanne) Goupil*, 1896, Ordrupgaard Collection, Copenhagen. This is one of the few portraits commissioned to Gauguin by the French settlers. It represents Jeanne, *Vaïte* in Tahitian, the youngest daughter of a rich notary who lived near Papeete.

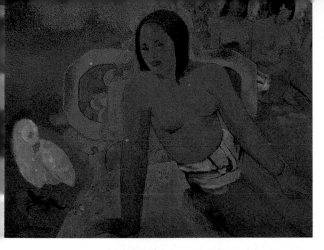

■ *Vaïraumati*, 1897, Musée d'Orsay, Paris. This work was inspired by the myth surrounding the origin of the Areois stock, one of the most important tribes in Tahiti. In *Ancient Maori Cult*, Gauguin tells how the Areois were born from the god Horo and from Vaïraumati, a beautiful girl from Bora Bora. The two figures in the back resemble the decorations at Borobudur.

■ *Why are you Angry?*, 1896, The Art Institute of Chicago. Gauguin reused the image of the hut from an earlier painting, *The Great Tree*. There are, however, considerable differences in the use of light and color, and in this work the characters play a more important role than the landscape. There are many conflicting critical opinions surrounding the title: in the works of this period, Gauguin tried to portray a variety of moods, and he often used subtle, even obscure hints.

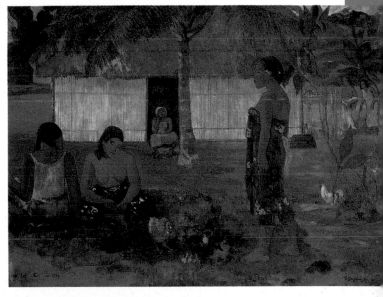

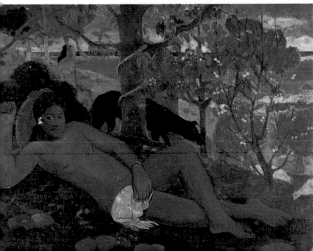

■ *The Noble Woman*, 1896, Pushkin Museum, Moscow. Gauguin described this painting in a letter to de Monfreid. The position of the woman closely resembles that of Cranach's *Diana's Rest*, of which Gauguin had a photograph. Due to her similarity with Manet's *Olympia*, she is also known as *Black Olympia*.

Don't do it!

The two Tahitians in this 1896 painting, *Eiaha ohipa* have the same position as two figures on a bas-relief in the temple of Borobudur, of which Gauguin had photographs. This work is now housed in the Pushkin Museum in Moscow.

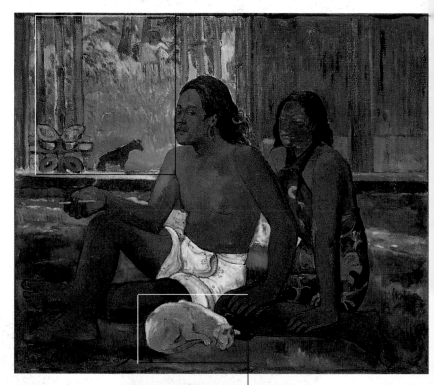

■ Much like the dog in the foreground in *Arearea* (p. 75), this sleeping kitten is portrayed with surprising naturalism. Its relaxed position contributes to the atmosphere of peace that emanates from the painting. This work mirrors the mood of Gauguin himself, who created it in a rare moment of inner contentment.

■ The landscape is created like a "painting within the painting", and it allowed Gauguin to play on the contrast between the semi-shade within the hut and the bright light outside. The trees underline the vertical rhythm of the composition, and the dark shade of the dog against the pale yellow background of the undergrowth becomes one of the focal points within the canvas. There is a third figure in the background whose role is unclear: it could be a self-portrait or just a character from Gauguin's dreams.

■ The theme of two figures in an interior facing a bright landscape reappears in an painting called *Te rerioa (The Dream)*, (1897, Courtauld Institute Galleries, London). In this particular painting, Gauguin decorated the walls of the interior with complex and mysterious symbols. The attitude of the two main characters is more allusive and ambiguous, and the presence of the sleeping baby in the cot, which is richly carved with anthropomorphic motifs, raises further questions.

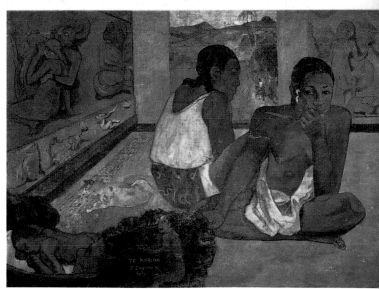

1898–1900: Papeete

Gauguin's paintings continued to be ignored in France and, in order to support himself and meet his medical bills, he started to work as a scribe at the land registry office in Papeete. Here he drew plans and copied documents for a mere six francs a day. At about the same time, he became more interested in journalism, and in print he started a personal battle against the local authorities, both religious and civil. The only result obtained by his campaign was attracting widespread hostility. He also wrote a pamphlet called *Modern Spirit and Catholicism*, in which he accused the contemporary, established church of losing sight of the true evangelical, Christian message. In 1899, after yet another spell in hospital, he paid off his debts with the money he had received from Paris, and left Papeete to return to his hut, where Pahura gave birth to Emile. In this more congenial environment, Gauguin resumed painting with renewed vigor: his last works achieved a perfect balance between color, simple, primitive style, and symbolic and allegorical meanings.

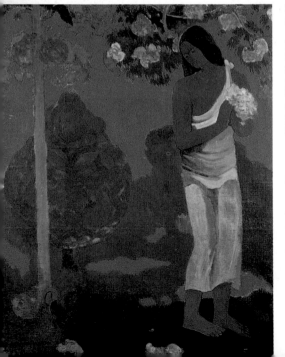

■ *Te avae no Maria (The Month of Mary)*, 1899, The State Hermitage Museum, St. Petersburg. The composition of this picture is very similar to another work, *Ruperupe (Luxury)*, painted in the same year.

■ *Two Tahitian Women*, 1899, The Metropolitan Museum of Art, New York. The wild, primitive spirit of the artist barely appears in this work: the figures resemble classical images, and the whole has a measured, dignified rhythm.

■ *The White Horse*, 1898, Musée d'Orsay, Paris. The pharmacist who had commissioned this painting rejected it because the horse was green. Gauguin sent it to de Monfreid who sold it to the Musée du Luxembourg.

■ *Te pape nave nave* (*Delightful Water*), 1898, National Gallery of Art, Washington. Gauguin did not want to portray nature the way it was: he therefore modified its colors, in order to give natural elements a symbolic value.

■ *Te atua* (*The God*). A wood-engraving created in about 1898, this is part of the "Suite Vollard".

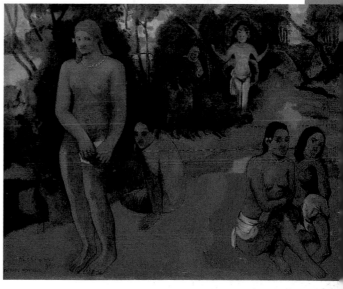

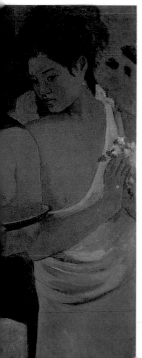

Gauguin the journalist

The son of a journalist, Gauguin had already demonstrated his fierce spirit in an article for the French magazine *Moderniste Illustré.* It appeared on September 21, 1889 and strongly criticized the state system of purchasing works of art. In his final Polynesian years he contributed to and edited a polemical magazine, *Les Guêpes* ("The wasps") which he eventually left to create his own satirical publication, *Le Sourire* ("The smile"), for which he wrote controversial, impulsive articles accompanied by his illustrations.

Where do we come from?

Where do we come from? What are we? Where are we going? measures 139 x 348 cm (54¾ x 136⅕ in). It is seen as the ideal synthesis of Gauguin's pictorial themes and outlook on life. This 1897 work is now in the Museum of Art in Boston.

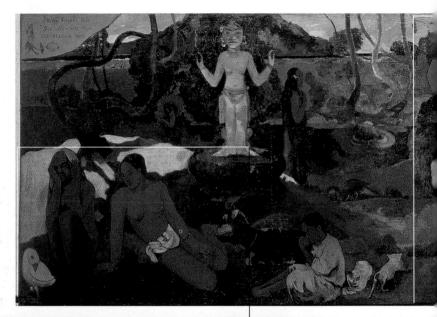

■ Gauguin included the first drawing for this in a letter to de Monfreid in February 1898. Before he created the canvas, he executed many sketches; then he worked on it day and night, for over a month. In July he sent it to Paris, where it was exhibited by Vollard: the critics were impressed by the stylistic solutions and profound symbolism. However, it was not a financial success: this and another eight of his paintings only earned him one thousand francs.

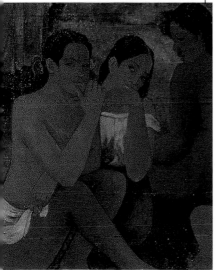

■ From the first time it was shown, this painting has been subject to many critical studies and interpretations. It has been seen as a metaphor of man, from infancy to adulthood, but also as a meditation on the meaning of life, or a comparison between nature and intellect, as exemplified by the two women sitting in deep thought.

■ Gauguin drew inspiration for this work from numerous sources. The composition is reminiscent of Puvis de Chavannes' *The Sacred Wood* and the figures recall bas-reliefs on the Temple of Borobudur. Gauguin reused figures from earlier works, but gave them a different role and meaning. Many critical theories have been put forward to explain the presence of the blue idol and the animals, especially "the strange white bird with a lizard between its claws, which represents the futility of words".

Searching for the "primitive"

■ This photograph, taken by Edward Quinr in about 1960, shows Pablo Picasso in his studio in the villa *La Californie* in Cannes. The artist holds one of his works, while a bronze figure from the Rurutu culture (Oceania) is visible on the right hand side. This was just one of the many artefacts from his rich collection of primitive art.

Until the mid-19th century, artists were expected to be familiar with classical and Renaissance art. Painting was dominated by unspoken dogmas such as perspective, symmetry, harmonious shapes, and the supremacy of design over color. Gauguin was one of the first to question the validity of these beliefs: his Polynesian paintings opened new horizons and offered a radically new set of aesthetic theories. Just as Europe was approaching its most significant phase from a technical, industrial, and scientific point of view, artists decided to look beyond Western culture and tradition and explore the artistic forms of "primitive" societies. The convention that limited artists to an accurate representation of three-dimensional space lost relevance as greater emphasis was given to decorative and expressive values, drawing was dramatically simplified, and artists adopted a freer use color and rhythm. The invention of the camera and the development of cinema meant that painting had definitely lost its role as a reflection of reality. In order to find a new dimension, many painters turned to the art of civilizations outside Europe to find the roots of human spirituality, unspoilt by progress, the local myths and symbols, and the ritual function of art.

■ Paul Klee, *Picture Album*, 1937, The Phillis Collection, Washington. From his first contact with the Blaue Reiter in 1911, Klee developed an interest in the artistic expressions of children and primitive cultures. He considered them the only true representations of a pure art arising from the depths of the human soul without any rational interference.

■ Constantin Brancusi, *Little French Girl*, 1914–18, The Solomon R. Guggenheim Museum, New York. One of a series of carved wooden sculptures, this resembles the statues from Guinea-Bissau and the Ivory Coast, and represents a stepping stone for abstract works executed after 1918.

■ Jean Dubuffet, *The Reveler*, 1964, Museum of Art, Dallas. Dubuffet was a supporter of Art Brut, that is of unspoilt and spontaneous artistic expressions created by children, the mentally ill, and "primitive" societies.

■ Max Ernst, *Head of a Man*, 1947, Private Collection, Paris. The influence of "primitive" idols is evident in much of Ernst's work.

■ Henry Moore, *Sketch for King and Queen*, 1952, Private Collection. In his early days, Moore studied the art of ancient cultures at the British Museum in London.

1901: the Marquesas Islands

At the beginning of 1901, Ambroise Vollard drew up a contract in Paris, in which he agreed to pay Gauguin 300 francs a month in exchange for 25 paintings a year. In August, after selling his property at a profit, the artist left his second Tahitian family, Pahura and his children and, in search of new artistic stimuli, sailed to the Marquesas Islands, about 1,400 kilometres northeast of Tahiti. Known by the natives as *Te henua enata*, or land of men, the Marquesas are 12 volcanic islands, only six of which are inhabited, divided into two groups over 100 kilometres apart. Dominated by luxuriant jungles and rocky mountains, the islands are surrounded by lava cliffs sheer above the Pacific Ocean, and offer unusual and grandiose landscapes. Gauguin settled in one of the southern islands, Hiva Oa, which was known at the time as Dominica. He soon realized with regret that the presence of religious missions had already altered the customs of the locals: they had lost their primitive social structure and were slowly absorbing the western culture Gauguin was vainly trying to flee.

■ *Still Life with Parrots and Idol*, 1902, Pushkin Museum, Moscow. Gauguin's travelling trunk appears in many still lifes of this period, often covered by a white tablecloth. It is portrayed here as a pagan altar upon which the gifts for the gods are neatly placed.

■ Tiki Figure, Private Collection. The native populations of the Marquesas Islands had developed complex art forms, especially with regard to tattooes.

■ *Sunflowers and Mangoes*, 1901, Private Collection, Lausanne. Van Gogh's favorite theme is expanded upon with the insertion of a disturbing flower-eye. The vase is unusual: it could have been one of Gauguin's creations.

■ *Still Life with Grapefruits*, c.1901, Private Collection, Lausanne. Although he considered still lifes a lesser form of art, Gauguin handled the subject on many occasions, creating several paintings of fine workmanship. This example recalls Cézanne's still lifes in the arrangement of the tablecloth and the fruit.

■ *Sunflowers on an Armchair*, 1901, The State Hermitage Museum, St. Petersburg. In order to satisfy Vollard's requests for pictures of flowers, which were selling well, Gauguin asked his French friends to send him some seeds. He planted them in the garden behind his hut. On the right-hand side of this painting there is a Maori portrait.

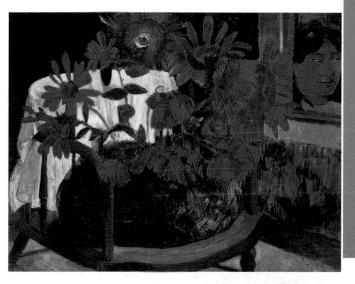

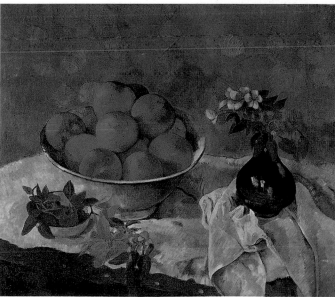

Riders

Rich in symbolic significance, this painting is considered as the spiritual heritage of the artist, who was by now aware of the closeness of death. Painted in 1901, it now hangs in the Pushkin Museum in Moscow.

■ Behind the two riders embarking on their journey towards the unknown, life goes on as it always has. This undertone of normality is exemplified by the scene being enacted on the beach, where a wooden boat is being prepared to sail. Color plays a larger role than outline or design, and there are many elements that anticipate informal abstract art.

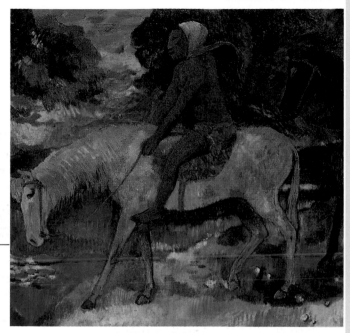

■ In this work Gauguin demonstrates his familiarity with classical art: the figure on the black horse resembles one on the frieze of the Parthenon. The character on the white horse is a *tupapau*, a Polynesian demon accompanying the young man to the next world. In the Pacific islands white is the color of mourning.

■ On the back of his manuscript *Before and After*, Gauguin attached a copy of Dürer's engraving *Knight, Death and the Devil*. The parallels between this and Gauguin's painting are obvious: they both portray the passage from earthly life to the other world.

LIFE AND WORKS

1902–03: the "House of Pleasure"

In the village of Atuana, Gauguin bought some land from the Catholic mission that had taken possession of the island, and commissioned the building of his last hut. He called it *Maison du Jouir*, or "House of Pleasure", and decorated it with carved and painted wooden panels portraying some of the motifs he had already used in his paintings and sculptures. It was an explicit provocation toward the missionaries, who were also concerned that his presence on the island might be a negative influence on local girls. Indeed, most natives considered him a friend, while the authorities saw him as a dangerous man inciting people to rebellion. He lived here with Marie Rose Vascho, a 14-year-old girl who gave him a daughter, Tahiatikaomata. Although ill and troubled by his problems with the authorities, he wrote, sketched, sculpted, and painted, realizing some of his masterpieces. On May 8, 1903, he died, probably following a heart attack. The only people beside him were Tioka, an old Maori sorcerer, and a Protestant minister called Vernier: even in death he underlined his double nature, that of a European man eager to live like a primitive.

■ *Riders on the Beach*, 1902, Private Collection, London. Although in this painting Gauguin pays tribute to Degas' paintings of the races at Longchamp, symbolism has by now superseded realism. The scene takes place by the sea, on a coral pink beach. The two hooded figures on the right-hand side resemble *tupapau*, guiding the other riders in their mysterious journey to the other world.

■ *Panels from the "House of Pleasure"*, 1902, Musée d'Orsay, Paris. These sequoia wood panels adorned the bedroom and studio of Gauguin's Atuana hut. The stylized shapes of the figures and the elaborate floral decoration highlight the primitivism of Gauguin's last Polynesian works. Victor Segalen, ship's doctor and the first witness to Gauguin's life in the Marquesas, described the "House of Pleasure" as "a sumptuous, gloomy interior, perfectly in keeping with his agony. It was magnificent and sad, and added the right hues to the last moments of Gauguin's vagabond life".

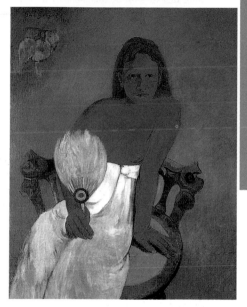

■ *Primitive Tales*, 1902, Museum Folkwang, Essen. The figure of de Haan, seated behind the girls, is transformed into a demonic being. He is meant to represent the clear rationality of the Western world threatening the purity of the two girls, who are symbolic of a lively, instinctive culture.

■ *Woman with a Fan*, 1902, Museum Folkwang, Essen. This red-haired woman, who also appears in *Primitive Tales*, is Tohotaua, wife of Haapuani (see p. 131). Gauguin used a photograph as a model, but he accentuated her melancholic expression.

Gauguin's legacy

Gauguin spent the last years of his life in voluntary exile and in his writings *Before and After* and *Stories of a Dauber* he lamented his feelings of loneliness and his colleagues' failure to understand his art. However, it was obvious from the very first posthumous exhibitions, such as that organized by Ambroise Vollard in 1903 and the one of 1906 at the Grand Palais, that his paintings would represent a major influence on 20th-century art. The Pont-Aven painters and the Nabis explicitly acknowledged his importance; soon Pablo Picasso, who was so impressed by the savage energy of primitive art that he used the sculpture *Oviri* as a model for his *Demoiselles d'Avignon*, joined them in celebrating Gauguin's talent. Henri Matisse, and many other Fauve artists, appreciated his intense colors and warm, glowing light. The German Expressionists agreed with his aesthetic theories and shared his interest in pagan idols and rituals. Even Abstraction has a debt to pay Gauguin: the whole movement developed out of his ideas on the superiority of color over outline and the importance of the spontaneous and immediate creative act. Thanks to his innovations, painting became more than just an instrument to describe nature: it also came to represent a free expression of the emotions and feelings the world had aroused in the artist and his imagination.

■ Max Beckmann, *Two Women*, 1946, Private Collection. The German Expressionists saw Gauguin as a master and a forerunner. In particular they were impressed by his wood-engravings, their simple contours and features.

■ Joan Miró, *Birds and Insects*, 1938, Private Collection. The Spanish painter Mirò was influenced by symbolic and Primitivist elements evident in Gauguin's work. He interest was in rendering the unconscious through physical images.

■ Pablo Picasso, *Woman sitting on a Green Background*, 1960, Private Collection. In 1905, when he was 24, Picasso moved to Paris. At Vollard's he had the opportunity to study the works that Gauguin had produced in the Marquesas Islands.

■ Henri Matisse, *Luxe, Calme, Volupté*, 1904, Musée d'Orsay, Paris. In 1899 Matisse bought several paintings from Vollard, including Gauguin's *Young Tahitian Boy with a Tiaré Flower*, which clearly influenced his painting style.

■ Wassily Kandinsky, *Improvisation 14*, 1910, Musée National d'Art Moderne, Paris. The creative path of this Russian artist took him from figurative art to abstract paintings. Throughout this development, Kandinsky bore in mind Gauguin's experiments with the expressive potential of color, which he used in its pure form, without reference to the natural world.

The Sorcerer of Hiva Oa

With this work, painted in 1902, Gauguin achieved a perfect balance between light and color; the characters seem to inhabit an enchanted landscape steeped in a dreamlike atmosphere. It is now in the Musée d'Art Moderne, Liège.

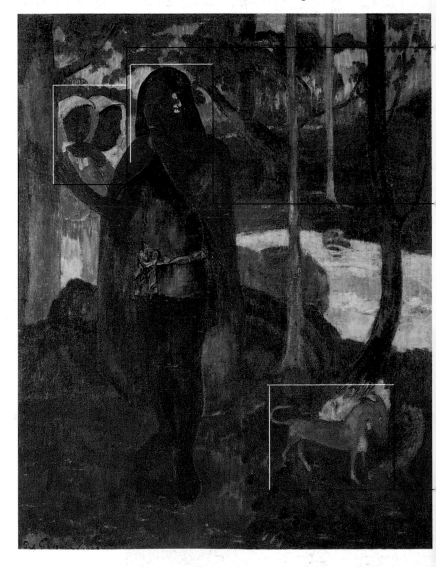

■ For the portrayal of the two women, Gauguin used the same image he had created in the foreground of another painting from the same year, *The Call* (Museum of Art, Cleveland). Although he only applied minor differences, the end result is quite different.

■ The figure in the red cloak is usually identified with Haapuani, a native sorcerer, who became a master of ceremonies with the arrival of the missionaries. Haapuani "loaned out" his wife, Tohotaua, who Gauguin used as a model for his 1902 painting *Woman with a Fan*.

■ The fox and the bird, partly real and partly fantastic, have been associated to ancient religious practices of the Marquesas Islands, by which Gauguin was fascinated. Their role and meaning in this painting are not exactly clear, and this sense of uncertainty heightens the mysterious atmosphere that permeates the whole composition.

BACKGROUND

Gauguin and the cinema

Gauguin's life has provided the inspiration for many films, but only few directors have been able to avoid the emphatic, stereotypical portrayal of the misunderstood, wretched artist. In 1942 Albert Lewin directed *The Moon and Sixpence*, from William Somerset Maugham's eponymous novel. A more famous effort is *Lust for Life*, directed in 1956 by Vincente Minnelli and expertly acted by Kirk Douglas and Anthony Quinn. The film narrates van Gogh's life, focusing on the period at Arles and his tormented friendship with Gauguin. *The Life of Gauguin*, with Donald Sutherland and Max Von Sydow, was directed by Henning Carlsen in 1986. The film concentrates on the painter in Paris after his first journey to Tahiti and narrates his difficult economic conditions and family life, as well as his desperate efforts to become a known, accepted artist.

■ *Landscape with Tahitian Women*, 1893, Private Collection. On June 27, 1995, Sotheby's of London sold this canvas for £5 million.

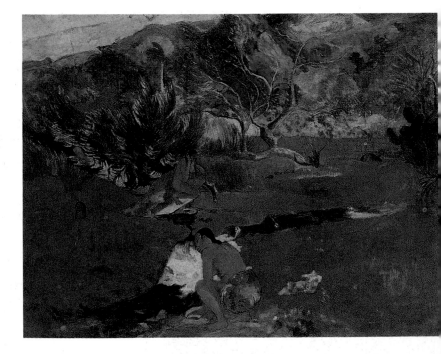

■ Anthony Quinn won an Oscar for his role in *Lust for Life*. He effectively communicated Gauguin's expressive fury, his creativity, anger at being misunderstood, loving outbursts, and human weaknesses.

■ Prominent among the many documentaries are *Gauguin* by Alan Resnais (1951), *Gauguin the Savage* by Felder Cook (1979), *Van Gogh and Gauguin*, produced in Italy in 1980, and *Within the Painting* from 1993.

■ *Te Fare (The House)*, 1892, Private Collection. On November 7, 1991 this painting was presented in Paris by Ader Tajan and subsequently sold for 52 million French francs.

The price of a Gauguin

Although while he was alive Gauguin struggled to sell his paintings for a few hundred francs, today his works are sought out by museums and art collectors from all over the world. The price of his engravings starts from $2,000 to $3,000, up to the $266,000 paid for *Tahitienne nue de dos assise*, a 1902 monotype (Christie's, November 1997). His sculptures and sketches command even higher prices: a buyer paid almost $1 million for his 1891–93 *Tahitian Women* (Sotheby's, November 1996). The highest figures are achieved for his paintings, such as the $10 million paid for the 1889 *Entre le lys* (Sotheby's, November 1989) or the $4 million for the 1885 *Self-portrait in front of the Easel* (Christie's, May 1997).

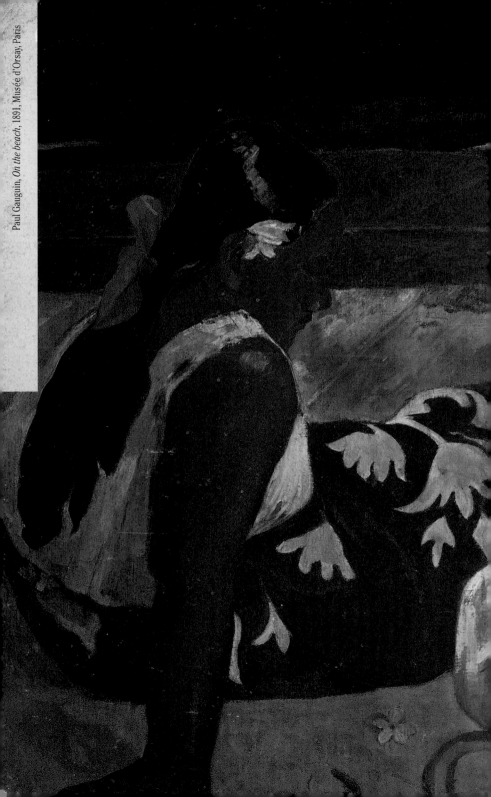

Index

■ *There is the Temple,*
1892, Museum of Art,
Philadelphia.

■ *Man with an Axe*, 1891, Private Collection, Basel.

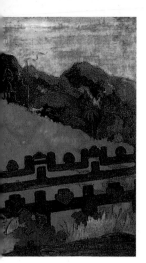

■ *Words of the Devil (Eve)*, c.1892, Kunstmuseum, Basel.

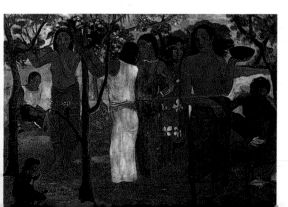

■ *Delightful Day*, 1896, Musée des Beaux-Arts, Lyon.

■ *Near the Sea*,
1891, National Gallery
of Art, Washington.

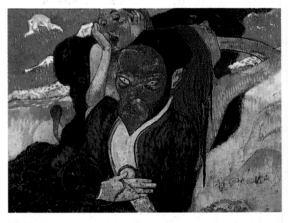

■ *Meyer de Haan*,
1889, Hartford,
Wadsworth Atheneum,
New York.

■ *Self-Portrait near Golgotha*, 1896, Museu de Arte, São Paolo.

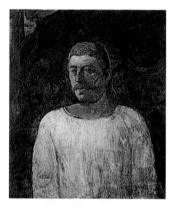

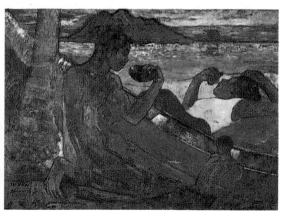

■ *The Canoe*, 1896, The State Hermitage Museum, St. Petersburg.

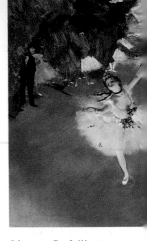

Note

All the names mentioned here are artists, intellectuals, politicians, and businessmen who had some connection with Gauguin, as well as painters, sculptors, and architects who were contemporaries or active in the same places as Gauguin.

Amiet, Cuno (Soletta, 1868 – Oschwand, Bern, 1961), Swiss painter, graphic designer, and sculptor. In 1892, after moving to Pont-Aven, Amiet became part of Gauguin's circle. On his return to Switzerland, he befriended Hodler and joined Die Brücke for a short time. Together with Hodler, he is recognized as one of the main exponents of Art Nouveau in Switzerland, p. 46.

Annah, 13-year-old Javanese girl, Gauguin's lover and his model in several works, pp. 98, 100, 101, 104.

Arosa, Gustave, businessman, photographer, and modern art collector. Arosa was one of the first to take an interest in the art of the Impressionists. He was Gauguin's guardian, and profoundly influenced his artistic development, pp. 8, 12, 99.

Ballin, Mogens (Copenhagen, 1872–1914), Danish painter. He was one of Gauguin's most daring students in terms of technique, pp. 46, 47.

Bambridge, Suzanne, wife of a dignitary in Paapete, who introduced Gauguin to the natives and their customs, pp. 68, 84.

Bernard, Émile (Lille, 1868 – Paris, 1941), French painter. Bernard worked with Gauguin and Paul Sérusier in Pont-Aven, developing a style known as Cloisonnism. He later came under the influence of the Nabis, pp. 32, 40, 42, 46, 51, 54, 57, 60, 64, 97.

Bevan, Robert Polhill (Hove, Sussex, 1865 – London, 1925), English painter. He studied art at the Westminster School of Art in London, p. 46.

Bonnard, Pierre (Fontenay-aux-Roses, 1867 – Le Cannet, 1947), French painter. He was one of the founders of the Nabis movement, pp. 108, 109.

■ Pierre Bonnard,
A Visit, 1902,
Private Collection.

Cézanne, Paul (Aix-en-Provence, 1839–1906), French painter. Initially associated with Impressionism, in his maturity he became increasingly committed to form and structure, pp. 12, 16, 20, 21, 32, 43, 49, 64, 102, 108, 123.

Corot, Jean-Baptiste-Camille (Paris, 1796–1875), French painter. An important landscape artist, Corot's works were particularly influential for the Barbizon School of painters and the Impressionists, pp. 17, 20.

Degas, Germain-Hilaire-Edgar (Paris, 1834–1917), French painter and sculptor. He began by painting portraits and history paintings, but from 1861 he is associated with Manet and the Impressionists. He had a preference for contemporary subjects, such as horseraces, ballerinas, theatre rehearsals, and café scenes, which he portrayed from a new perspective and with an almost photographic quality, pp. 18, 19, 21, 32, 55, 61, 92, 126.

■ Edgar Degas, *A Dancer Curtseying*, 1878, Musée d'Orsay, Paris.

■ Edouard Manet, *The Fifer*, 1866, Musée d'Orsay, Paris.

Delacroix, Eugène (Carenton-Saint-Maurice, 1798 – Paris, 1863), French painter. His romanticism is expressed in the dynamism of his works. His travels to Morocco and Algeria had a profound influence on his use of color and light, pp. 17, 20, 45, 87, 95.

Du Puigadeau, Ferdinand (Nantes, 1864 – Le-Croisic, 1930), French painter. After many trips to Tunisia and Brussels, he settled in Pont-Aven, where he met Gauguin and Laval. His main interest was in landscapes and night scenes, and he created many works portraying the festivals of Pont-Aven, p. 46.

Durand-Ruel, Paul (Paris, 1831–1922), French art dealer and gallery owner. A supporter of the Impressionists, from 1870 he contributed to the diffusion of their works, pp. 12, 16, 92.

Gad, Mette Sophie, Gauguin's first wife and a friend of Arosa's family, pp. 12, 13, 18, 24, 36, 92.

Gauguin, Aline (1877–97), Gauguin's daughter, his second born. She died of pneumonia aged 20, pp. 12, 54, 112.

Gauguin, Clovis (1879– ?), Gauguin's son, his third born, pp. 12, 18, 32.

Gauguin, Emile (1874– ?), Gauguin's son, his first born, pp. 12, 54.

Gauguin, Jean-René (1881– ?), Gauguin's son, his fourth born, p.12.

Gauguin, Marie, Paul Gauguin's sister, p. 32.

Gauguin, Paul (1883– ?), Gauguin's son, his fifth born, p. 12.

Gloanec, Jean-Marie, owner of the Pont-Aven inn where Gauguin used to stay, pp. 32, 40, 99, 104.

Guillaumin, Armand (Moulins, 1841 – Paris, 1927), French painter. He exhibited in many Impressionist shows. His paintings are mostly of urban landscapes and industrial subjects, pp. 15, 16, 20, 25.

Hugo, Victor (Besançon, 1802 – Paris, 1885), French poet, dramatist, and novelist. The most important of the French Romantic writers, his opus includes poems, historical novels, political writings, and novels with a humanitarian message, pp. 26, 45, 50, 97.

Jongkind, Johan Barthold (Lattrop, 1819 – Cote-Saint-André, 1891), Dutch painter and etcher. An admirer of Corot, he specialized in landscapes, pp. 15, 16.

Laval, Charles (Domme, Dordogne, 1864–92), French painter. In 1886 he met Gauguin in Pont-Aven and accompanied him on his first trip to Martinique, pp. 31, 33, 36, 40, 47, 64.

Maillol, Aristide (Banylus-sur-mer, 1861–1944), French sculptor, graphic designer, and painter. He started his artistic career as a painter, but soon showed a predilection for sculpture. Limiting himself almost exclusively to the female nude, his style was calm and

■ Paul Cézanne, *Card Players*, 1893–96, Musée d'Orsay, Paris.

■ Camille Pissarro, *The Dunes at Knocke*, 1902, Private Collection.

meditative with smooth, sinuous lines pp. 82, 108, 109.

Manet, Edouard (Paris, 1832–83), French painter. At the Salon des Refusées in 1863, his painting *Le Déjeuner sur l'Herbe* caused a scandal among critics and public alike. He eliminated perspective and fine tonal gradations, creating strong contrasts of light and shade. After 1870 he became associated with the Impressionists, pp. 16, 21, 56, 96.

Matisse, Henri (Le Cateau, 1869 – Cimiez, 1954), French painter and sculptor. Throughout his long artistic career, Matisse came into contact with many different styles of painting from Impressionism to abstraction, although he was never wholly allied to any particular movement. His works are characterized by a chromatic radiance and strong outline that earned him the

nickname *fauve,* meaning "savage", pp. 69, 82, 102, 128, 129.

Meyer de Haan, Jacob (Amsterdam, 1851–95), Jewish painter. In 1889 he joined Gauguin at Le Pouldu, where he paid for Paul's rent in exchange for art lessons. He specialized in still-life painting which was influenced by the Flemish masters and their warm, intense colors, pp. 46, 54.

Monet, Claude (Paris, 1840 – Giverny, 1926), French painter. Possibly the main exponent of Impressionism, he tried to portray on canvas the most ethereal things such as snow melting and the misty effects of smoke and steam. His research led him to represent the disintegration of form in light, for which he went beyond the mere pictorial image of the visual sensation, pp. 12, 16, 18, 20, 21, 64.

Monfreid, Daniel de, friend of Gauguin, whom he met in Paris in 1887. Monfreid took over Schuffenecker's role as correspondent and confidant during Gauguin's periods in the Pacific, pp. 57, 64, 92, 104, 112, 117.

Moscoso, Flora Tristan (1803–44), Gauguin's maternal grandmother. A journalist and novelist, in 1838 she published her autobiography, *Wanderings of an Outcast*, p. 8.

Pissarro, Camille (Saint-Thomas, 1830 – Paris, 1903), French painter. A founder member of the Impressionist group, Pissarro was the only artist who exhibited at all eight Impressionist shows. During the 1880s, under the influence of Seurat and the Neo-Impressionists, he briefly adopted a pointillist technique, but later reverted to the Impressionist style, pp.12, 13, 16, 17, 18, 19, 20, 24, 25, 32, 64.

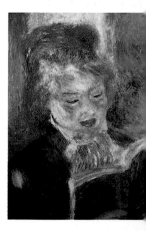

■ Pierre Auguste Renoir, *La lectrice*, 1874–76, Musée d'Orsay, Paris.

■ Henri de Toulouse-Lautrec, *La clownesse Cha-U-Kao*, 1895, Musée d'Orsay, Paris.

■ Edouard Vuillard, *The Sofa*, 1910, Private Collection.

A DK PUBLISHING BOOK
Visit us on the World Wide Web at http://www.dk.com

TRANSLATOR
Sylvia Tombesi-Walton

DESIGN ASSISTANCE
Joanne Mitchell

EDITOR
Jo Marceau

MANAGING EDITOR
Anna Kruger

Series of monographs
edited by Stefano Peccatori and Stefano Zuffi

Text by Gabriele Crepaldi

PICTURE SOURCES
Archivio Electa, Milan
Alinari-Giraudon, Florence
Archivio Scala, Antella
Archivio Mondadori, Segrate
Agenzia Ricciarini, Milan
Elemond Editori Associati wishes to thank all those museums and
photographic libraries who have kindly supplied pictures, and would be pleased
to hear from copyright holders in the event of uncredited picture sources.

Project created in conjunction with
La Biblioteca editrice s.r.l., Milan

First published in the United States in 1999 by DK Publishing Inc.
95 Madison Avenue, New York, New York 10016

ISBN 0-7894-4147-0

Library of Congress Catalog Card Number: 98-86752

First published in Great Britain in 1999
by Dorling Kindersley Limited,
9 Henrietta Street, London WC2E 8PS

A CIP catalogue record of this book is available from the British Library.

ISBN 0751307319

2 4 6 8 10 9 7 5 3 1

Printed by Elemond s.p.a. at Martellago (Venice)